The Campus History Series

WESTERN ILLINOIS

UNIVERSITY

JEFFREY W. HANCKS AND ADAM J. CAREY

The Campus History Series

WESTERN ILLINOIS UNIVERSITY

JEFFREY W. HANCKS AND ADAM J. CAREY

ARCADIA
PUBLISHING

Published by Arcadia Publishing
Charleston SC, Chicago IL, Portsmouth NH, San Francisco CA

Printed in the United States of America

Library of Congress Control Number: 2008938611

For all general information contact Arcadia Publishing at:
Telephone 843-853-2070
Fax 843-853-0044
E-mail sales@arcadiapublishing.com
For customer service and orders:
Toll-Free 1-888-313-2665

Visit us on the Internet at www.arcadiapublishing.com

CONTENTS

ACKNOWLEDGMENTS

There are several individuals on the Western Illinois University (WIU) campus who have made the publication of this book infinitely easier. Dr. Phyllis C. Self, dean of university libraries, recognized early on the importance of this project, and she made available the necessary institutional financial support to proceed. Darcie Shinberger and her fantastic staff in the WIU Visual Productions Center, especially Brian Kreps, provided many of the modern campus photographs. Virginia Jelatis, associate professor and director of graduate studies in the WIU Department of History, encouraged us to pursue this endeavor as an applied project for Adam J. Carey's master's degree in history. As always, the contributions of the WIU Archives and Special Collections Library staff did not go unnoticed. Bill Cook, Kathy Nichols, Heather Richmond, and Marla Vizdal helped locate and select images and provided a great deal of support with the text content. Welcome to Western, Heather! We hope you find your work and life here challenging and fulfilling. We are so glad you chose us. Marla, your long and distinguished career in the archives is recognized and respected. Best of luck as you enter the next phase in your life. Thanks for your service and your friendship.

We hope this volume reinforces WIU's impressive history previously detailed in other institutional histories and adds to it for the years never before analyzed. WIU is now in its second century of service to the people of Illinois, and we look forward to many more years of contributions to citizens all across Illinois and beyond.

All images are courtesy of Archives and Special Collections, Western Illinois University Libraries.

INTRODUCTION

As the United States grew and developed in the last quarter of the 19th century, the need for well-prepared schoolteachers was acute. Local communities pursued trained teachers intensely, but there were not enough qualified instructors to fill the need. States responded by opening a series of normal schools to train teachers. The state of Illinois followed this trend, and by 1895 the state had opened normal schools in all parts of Illinois, except for the western part of the state.

Intent upon bringing a normal school to the area, civic leaders from throughout the western Illinois region lobbied legislators heavily in Springfield. Those leaders all had ulterior motives, namely to bring the school to their home communities. When the decision was made to support a school, the regional competition was on. Aledo, Monmouth, Quincy, Rushville, and Macomb headlined the contest. In the end, due in large part to the work of the influential Macomb native and Speaker of the Illinois House L. Y. Sherman, Macomb was selected.

The state did set one special requirement for the state's newest normal school. As the state had opened numerous normal schools in the preceding years, the need for another one was not great. Therefore western Illinois' normal school was commissioned to concentrate solely on the training of rural teachers. The charter was signed in 1899, construction began, and in 1902, the first students started classes at Western Illinois State Normal School (WISNS).

WISNS's growth and development parallels other normal schools. In its earliest years enrollment was low, never eclipsing several hundred students. The curriculum was focused solely on teacher training. Campus life centered around a select few buildings; Sherman Hall being the most prominent. A second important building was Simpkins Hall, which housed WISNS's well-respected laboratory school. The laboratory school provided wonderful opportunities for WISNS students to gain practical experience in the classroom before embarking on their own professional teaching careers. Through it all, WISNS was a tightly knit community of students, faculty, staff, and administration.

WISNS's strong sense of community only grew as the school got larger. Athletic programs found success on the playing fields, musical groups entertained with well-received performances, and theater students dazzled with their stage performances. Greek organizations arrived and contributed positively to campus and local civic groups. The residence halls promoted community engagement and built a sense of school pride.

As WISNS grew, so did its name. WISNS became Western Illinois State Teachers College, which became Western Illinois State College, and in 1957, Western Illinois University (WIU). As with colleges nationwide, the school experienced explosive growth after World War II and throughout the 1960s as veterans and baby boomers flooded the campus. Western Illinois University responded by constructing a great number of new facilities and hiring a much larger faculty and civil service workforce. Traditional curricular programs in education were expanded, and additional programs in business, the

humanities, fine arts, and other areas were added, representing a more diverse selection of disciplines.

The WIU experience is not limited to Macomb-based students. WIU has a long tradition of providing educational access and opportunities for nontraditional students, and technological advances make this easier. Over the years WIU's faculty has traveled to locations throughout Illinois to teach classes. WIU's presence in the Quad City area is particularly strong. Classes began in rented space and later shifted to WIU's own facility, the Rock Island Regional Undergraduate Center. Currently WIU-Quad Cities is a coequal campus, with grand plans well underway to build a new campus along the Mississippi River in Moline. WIU has also embraced the potential of the Internet to bring educational opportunities beyond Illinois' borders. Today students earn WIU undergraduate and graduate degrees without ever traveling to Macomb or Moline.

As the western Illinois region's public university, WIU has a special commitment to its home region. For example, the university archives preserves the region's printed culture, and the Central Illinois Adult Education Service Center and Learning Is ForEver program support lifelong learning opportunities. The Illinois Institute for Rural Affairs has a statewide mission to conduct research into improving the lives of residents in the state's rural counties.

Researchers interested in WIU's history are fortunate to have two outstanding books to consult. *The Purple and the Gold: The Story of Western Illinois University* by Dr. Victor Hicken is a narrative history of the school from its founding through the tremendous growth period of the 1960s. *First Century: A Pictorial History of Western Illinois University* by Dr. John Hallwas documents WIU's rich history in photographs and text through the 1990s. Both books tell WIU's history in a level of detail outside the scope of this book and should be considered authoritative resources. This book is a similar photographic journey through WIU's history, with a special emphasis placed on the years 2000 to today, as these years are not documented in the previous books. It is organized around WIU's presidents. As with other universities, major changes often took place when new presidents arrived, infusing their own visions for the school's journey forward. Presidential administrations seemed a logical way to present WIU's history across the decades.

WIU's growth and development mirrors closely many midwestern colleges with normal school origins. However, its familiar tune should not trivialize the genuine impact WIU has had on improving the lives of Illinois citizens and those residing beyond the Land of Lincoln's borders. WIU has a proud history, and in the future, WIU will remain an increasingly important economic and cultural engine for the state of Illinois and the Midwest.

One

HENNINGER AND BAYLISS
1899–1911

As described in this volume's introduction, the process of selecting Macomb as the location for Western Illinois State Normal (WISNS) was complicated. Once Macomb won the competition and plans were finalized, construction began in 1900. A building the size and complexity of Sherman Hall had never been built in rural west central Illinois, and its construction provided numerous logistical challenges of getting supplies and a qualified labor force to the building site. In early 1902, the roof was put on Sherman Hall, and the all-purpose building was nearly ready for use.

Classes began at WISNS in September 1902. WISNS's first president, John W. Henninger, had attracted a quality faculty to Macomb, promising them the unique opportunity to be part of a new educational experiment from the ground floor. The initial student body was a good size. Nearly 230 students enrolled in the teacher education program, and approximately 100 boys and girls attended the first through eighth grades offered at the laboratory school.

Room and board was the primary expense for early WISNS students. Most students agreed to teach in Illinois upon graduation. In return, their tuition was waived. For between $1 and $5 each week, students could rent a room in a private home or in a boardinghouse. Providing services to the influx of new students was an economic boom for local residents and retailers. Stores began catering to students, and students responded by bringing in outside dollars to Macomb.

Alfred E. Bayliss became WISNS's president in 1906. The English-born Civil War veteran proved a capable administrator and effective leader for the growing school. Bayliss attracted many new quality faculty members to Macomb, and he spearheaded the drive to open a four-year high school at WISNS. In time, Bayliss became popular with the students. His tragic death in 1911 was mourned by the entire campus community.

WISNS's first 10 years were a period of great growth and development for the new school. There were the natural growing pains along the way, but for the most part the decade was a success. Presidents Henninger and Bayliss put WISNS on a path of continuous improvement that would serve the school well as future presidents faced the many challenges that lay ahead.

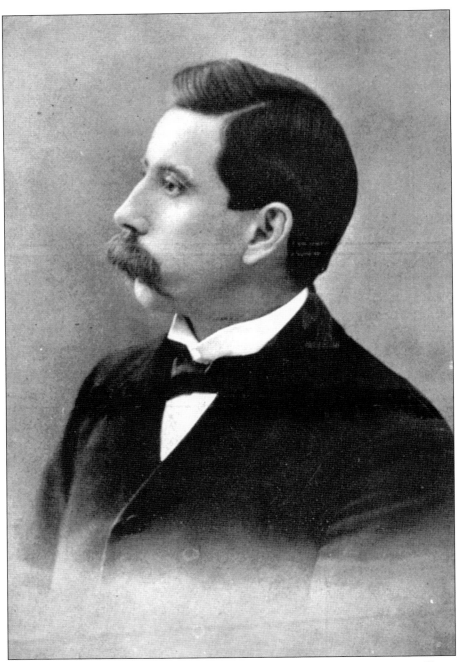

WISNS's first president was John W. Henninger. Born in 1857 in Hagerstown, Henninger received his bachelor's degree from McKendree College in 1881. While at WISNS he taught psychology and management courses, and he was paid a salary of $291.66 per month. Henninger hired nine teachers for the normal school, one librarian, and three instructors for the training school before his resignation in 1905. After WISNS, Henninger completed a master's degree at the University of Chicago and taught in Bloomington until his death in 1918.

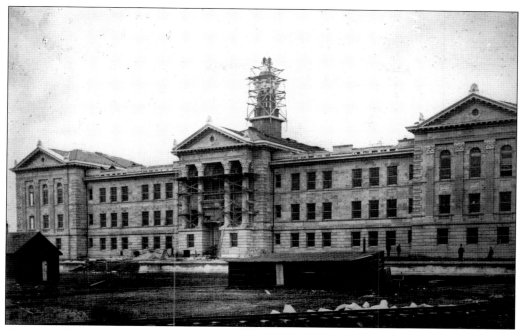

Western Illinois University's signature building, stately Sherman Hall was the original building on the WISNS campus. Construction began on the building in 1900 and wrapped up in 1902. Measuring 325 feet long, 86 feet deep, and three stories high, Sherman Hall was the only campus facility when WISNS opened. Therefore, it contained all the rooms the school required, including classrooms, laboratories, a library, meeting halls, a museum, and an auditorium. In these pictures, work continues on WISNS's famous cupola (above). Below, WISNS had to install wooden planks for people to walk on to stay out of the mud before the sidewalks and other landscaping finishing touches were completed.

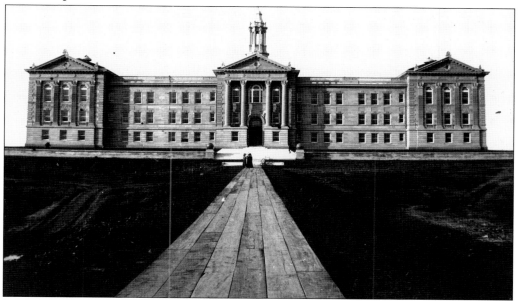

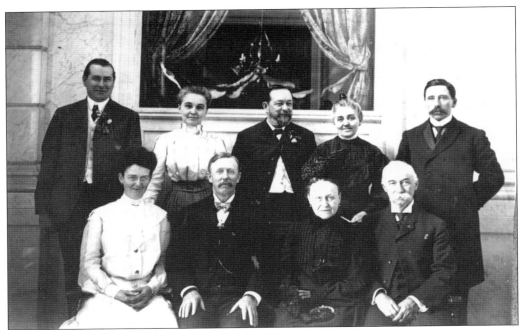

Western Illinois University (WIU), like most universities, is governed by a board of trustees. In Illinois, the board of trustees is appointed by the governor, with one representative elected by the student body. Members of the board of trustees work hard at promoting the university and attend many of the school's functions. In this picture, members of the board and their wives pose with WISNS president John W. Henninger.

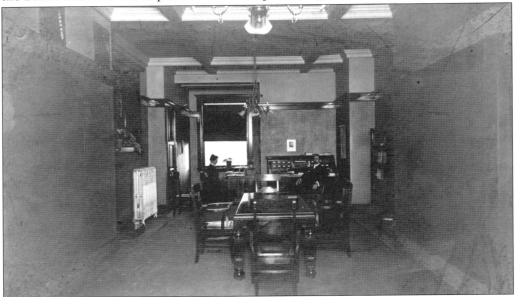

President John W. Henninger was a very active president who worked exceptionally hard on behalf of the young school. In this *c.* 1900 picture, Henninger is seated at his desk in the sparsely decorated presidential office in Sherman Hall. Henninger's secretary is seated at her desk in an alcove attached to the office.

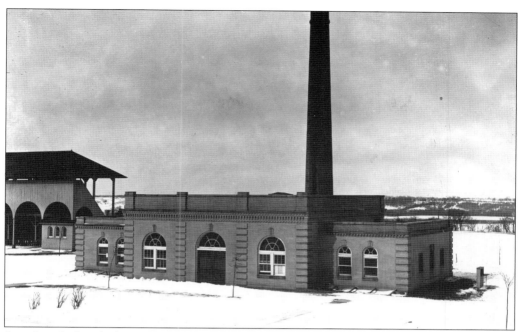

Standing behind Sherman Hall, the public services building was constructed in 1900 as the power plant and boiler for WISNS. The Western Academy, renamed the Western Teachers College High School in October 1943, used this building for many years prior to 1957, when it was converted back into a service building. Since 1970, the university art gallery has permanently resided there.

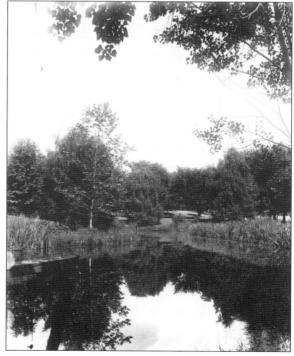

Lake Ruth, in the southwestern quadrant of campus, is a peaceful retreat for students, faculty, and staff looking to escape from the daily grind of academic life. Lake Ruth was an integral part of an ambitious campus beautification project that began in 1908. Generations have enjoyed resting along the lake's shores, studying, socializing, or simply reconnecting with nature.

THE

MILITARY

TRACT

"If I mistake not, the object of those who were prominent in originating the measure establishing this school, and who were active in securing its enactment into law, was to make special provision for those who were to teach in our COUNTRY SCHOOLS.

This purpose was highly commendable and patriotic."

—*John R. Tanner, Governor of Illinois, December 21, 1902.*

WESTERN ILLINOIS STATE NORMAL SCHOOL
AT
MACOMB, ILL.

PRINCIPAL'S REPORT
REGISTER
1906:07

One of the most important publications a university produces is its annual bulletin. Bulletins include vital information about the admissions requirements, degrees offered, course descriptions, academic calendar, costs, administration, and faculty credentials. It is a publication all students should have a copy of, as its contents serve as a contract between students and the institution. This 1906 bulletin contains all the pertinent information for students on campus during that academic year.

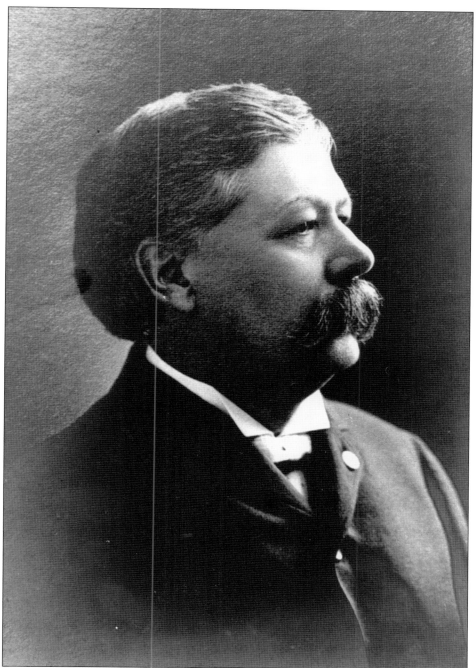

Alfred E. Bayliss was the Illinois superintendent of public instruction before accepting the position as WISNS's second president. Born in England in 1847, Bayliss and his family came to the United States in 1853. After serving in the Michigan Calvary during the Civil War, Bayliss earned undergraduate and graduate degrees from Hillsdale College. Bayliss took a special interest in campus beautification projects, including the construction of Lake Ruth. Bayliss died in office in 1911 at the age of 64.

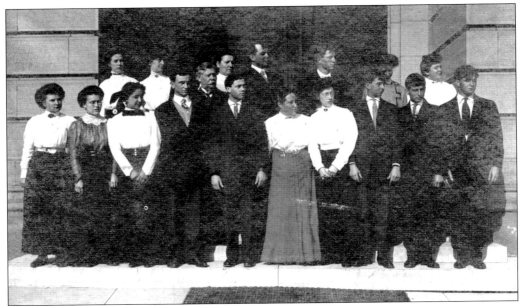

Standing just outside Sherman Hall on a warm January 28, 1910, a group of WISNS students and employees pose for a photograph. Included in the photograph are WISNS president Bayliss (first row, fifth from left) and, just over his left shoulder, Dean Grote.

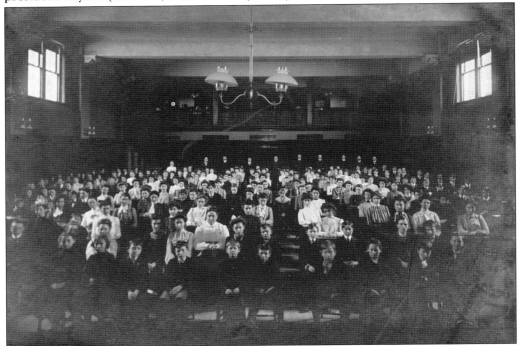

This image, from the 1902–1903 school year, shows the student body together in Sherman Hall for an assembly. The youngest children sat up front, and the older students sat behind them. In the back, members of the faculty stand and maintain order. This image was donated to the WIU archives by the Sticklen family.

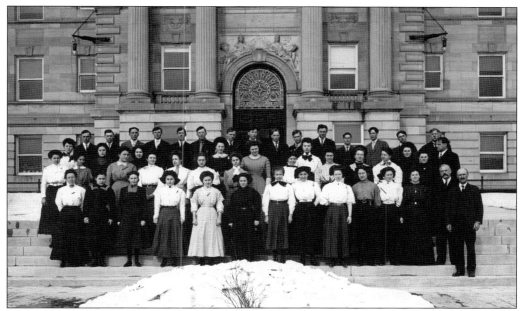

This incredibly clear photograph, taken outside Sherman Hall around 1910, shows numerous WISNS students, teachers, and administrators standing near a large snow pile. President Alfred E. Bayliss is standing in the top row in the right-hand corner.

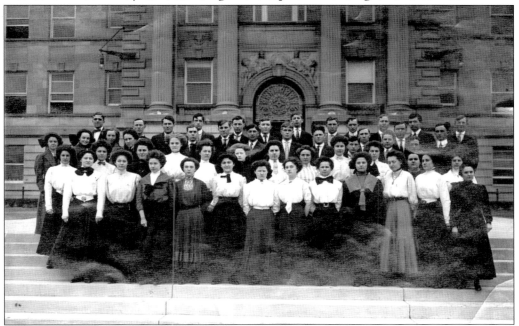

Western Academy provided area high school–aged students the opportunity to learn from the highly educated faculty of WISNS. The academy also acted as a real-world classroom for normal school students to apply their teacher training before leaving for their country school assignments across Illinois. This photograph, taken in front of Sherman Hall, shows students in that era's customary school dress.

The Western Courier.

VOL. IX, No. VIII MACOMB, ILLINOIS, Oct. 8, 1911. COPY 5 CENTS

ENTERED AS SECOND-CLASS MATTER MAR. 3, 1908, AT THE POST OFFICE AT MACOMB, ILLINOIS UNDER THE ACT OF CONGRESS OF MARCH 3, 1879.

A WORD OF APPRECIATION

THE SCHOOL HAS LOST A TRUE FRIEND

It is altogether fitting that the Courier should give a full account of the life and work of our honored principal, and in the near future such will be done. At present we can but express our grief and sympathy with those who most grieve, and express briefly our sense of loss in coming together for the new school year to find that Mr. Bayliss has gone from us. It is easily seen that the student body feels keenly his death, and the flag at half-mast is but a feeble expression of our feeling of personal loss.

It is most sad that he should have to go just when his real influence began to be truly felt and understood. These first five years was a kind of clearing the way; his planting now begins to bear fruit and, if he could have remained a few years longer, he would have realized a larger measure of satisfaction than his innate modesty would permit him to hope.

The normal school problems Mr. Bayliss had undertaken are of such character that time is required to bring results. He led in the educational and social betterment of the one room rural school. Already a number of graduates of this school have chosen to teach in the country in preference to the town, and the results have been exceedingly gratifying.

Normal school extension by correspondence he conceived to be a means of assisting those who were of such age and experience as would warrant their doing work in that way, and continue their work in teaching. A large number of students are now systematically pursuing some study along with their teaching.

The Country Club, as a means especially of raising the rural school as far as possible to the standard set by the Superintendent of Public Instruction, received his earnest support; and no student organization of last year showed such numbers or enthusiasm as the Country Club No. 1 organized here last summer.

The nearness and common sympathy of students and faculty of the Western Normal School is a larger expression of the freedom and can for with which he conferred with students. Under his administration the school has had gradual but positive growth into definiteness of organization, purpose and strength.

In this he did a splendid work, and his influence will be a part of its life and growth; but it is for those royal qualities of manhood that we will cherish the dearest recollections of Mr. Bayliss. What he thought should be done, he did without fear. He could look so coolly on all sides of a question and see the other man's viewpoint as well as his own. He seemed never to forget the one who needed and wanted a chance. His sympathies were broad and deep toward his fellows and toward truth and the open mind seemed the law of his life.

We were slow to understand him by the very fact of his modesty; for he did more kindnesses in secret than those seen. Truly he let not his left hand know what his right hand did. In this his life is a most beautiful lesson. But we who come to know him find many great lessons from his daily life. The dignity of work, the sanctity of true work was a law to him, and all who knew him in his work, know that he obeyed the law.

He was so fair in his decisions. Self-interest seemed to have no place in his nature and his sense of justice and truth eliminated prejudice. The purity of his life, public and private, put him in the front rank of earth's nobility. It is for these deep and abiding qualities of character that we shall honor and cherish the name of Alfred Bayliss.

The Young Men's Christian Association and the Young Women's Christian Association meet regularly in the Music Room and Platonian Hall respectively, every Tuesday at six forty five o'clock. All students are invited to attend one or the other of these meetings.

McGILVREY CHOSEN AS PRESIDENT

A MAN OF EXPERIENCE AND ABILITY

Immediately after the death of Mr Bayliss the Board of Trustees appointed John E. McGilvrey acting president of the school. Mr. McGilvrey was Director of the Department of Education and Supervisor of the training school last year and in that work has won the respect and friendship of faculty and students.

He graduated from the four year course at the Indiana State Normal School. Directly after graduating he taught in that school and was later principal of the Paris, Ill., high school.

He graduated from the Indiana State University, receiving the Bachelor's Degree from the school of Education and Philosophy. After this he was principal of the high school at Freeport, Ill. He left that position to be Assistant Professor of Pedagogy and High School Inspector at the University of Ill. In 1898 he became president of the Cleveland City Normal School remaining there ten years. Upon his resignation there he was chosen Superintendent of the Cleveland City Farm School at Hudson, Ohio, a school for delinquent boys. From that he came to this school. Last spring he was elected president of the Kent, Ohio, State Normal School now in the course of construction. The new position did not demand his entire time so at Mr. Bayliss' request he had consented to teach here this year.

The students who have been under his instruction are free in expressing their high estimate of his ability. The regret of all who know him is that he has to leave the school at the close of this year's work.

Here is the *Western Courier*, October 8, 1911, article about the death of WISNS president Alfred E. Bayliss.

Two

MORGAN
1912–1941

Walter Piety Morgan, WISNS's longest-serving president, oversaw the school during a period of tremendous change in the world. Arriving before World War I and staying until the middle of World War II, no president saw the world change more during his administration. And no president played a more pivotal role in the school's growth and development than Morgan.

Morgan was engaged in virtually every aspect of campus life. He was a man of strong Christian faith, and his religious beliefs influenced his work decisions. He made sure the students behaved as ladies and gentlemen, and therefore they were not allowed to smoke, drink, or dance. He was also engaged in the individual students' lives. He wanted to know who they were, where they came from, and listen to their future plans. He desired a family atmosphere at WISNS, a feeling the school's faculty and staff promoted with equal vigor.

World War I was a defining period for the young school. Classes continued, despite many male students leaving for war duty. President Morgan encouraged WISNS students to buy Liberty Bonds and support the war efforts. During this period, the campus facilities grew in number with the opening of the arts building (Garwood Hall) to join Sherman Hall and the women's building (Grote Hall).

The 1920s ushered in the debut of homecoming and the arrival of a campus legend. In 1923, Western Illinois State Teachers College (WISTC) celebrated its first homecoming, complete with assemblies, cheerleading, music, and of course football. WISTC's football team did not have a great tradition of success, but that was to change after 1926 when the legendary coach Ray "Rock" Hanson arrived in Macomb to begin a long tenure and winning traditions in WIU athletics.

The Great Depression of the 1930s did not curtail WISTC's growth. Student organizations continued to develop, athletics programs were successful, and WISTC built its first dedicated laboratory school facility (Simpkins Hall). Nearly 1,100 students enrolled at WISTC in 1939, its highest total ever. The figure was big enough to provide lots of extracurricular opportunities to students but small enough to retain its small-school flavor.

President Morgan's administration lasted all or part of four decades. Under his leadership, the small school he took over early in the second decade of the 20th century grew to become a teachers college with many more campus buildings, a larger enrollment, an excellent faculty, and a solid academic reputation throughout the state and region. Walter Morgan dedicated his entire career to WISTC, and his impact upon the school was significant.

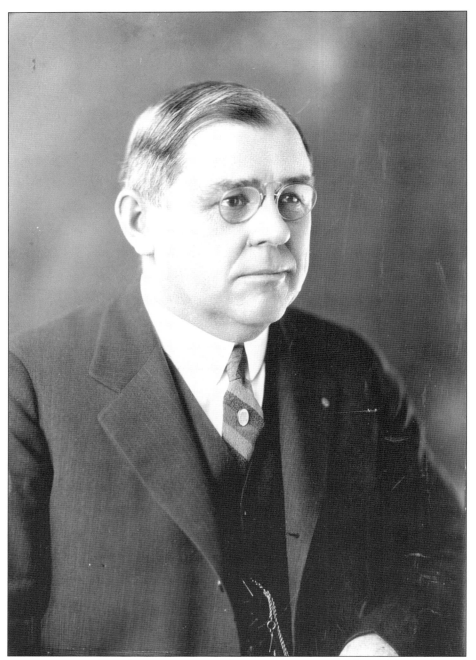

Born in Prairie Creek, Indiana, in 1871, Walter Piety Morgan graduated from the Indiana State Normal School in 1895. Five years later, he earned a bachelor's degree from Indiana University, and in 1912, a master's from the University of Chicago. Morgan became WISNS's third president in 1912. Under his direction, WISNS received national accreditation as a teachers college. One of Morgan's most significant hires was Ray Hanson, who was tapped to head the men's physical education department. Morgan retired in 1942, and he died 16 years later.

Here is Dr. Caroline Grote, dean of women.

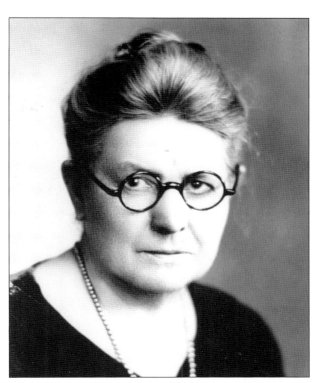

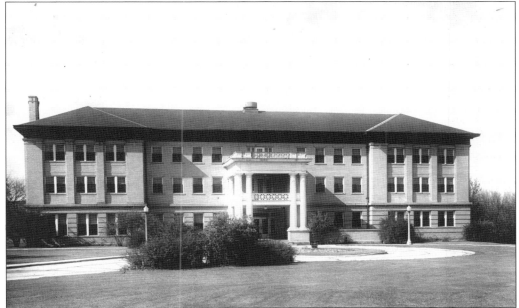

Monroe Hall, with its distinctive portico, opened as a residence hall for women in 1913. Located to the east of Sherman Hall, it housed 85 women in 42 rooms. Monroe Hall was managed for many years by the strict dean of women, Dr. Caroline Grote. Morgan Hall was renamed in honor of Dr. Grote in 1947, six years after her death. Vacant since 1973, Grote Hall was torn down in 1991.

The Western Courier.

VOLUME XVIII MACOMB, ILL., Nov 22, 1918. NUMBER 2

A VISITOR FROM ABROAD

VISIT OF MR. CAMILIO OSIAS.

The Normal has been honored the past week by a visit from Mr. Camilio Osias, of Manila, a graduate of our school in the class of 1908. Mr. Osias took his Master's degree from Columbia University in 1910, and since then has been engaged in educational work in the Philippines, in which he has achieved such marked success that he is now one of the three directors of the Bureau of Public Education for the Philippine Islands. Mr. Osias is in this country on a tour of inspection of schools and hopes, if posible, to return to Manila in the spring by way of Europe, in order to visit French and English schools. He will also spend some time in studying the Japanese educational system.

The students and townspeople had the opportunity of hearing two very interesting and instructive addresses from Mr. Osias, one in the Presbyterian church last Sunday and the other in chapel on Tuesday.

FACULTY NEWS.

This year there have been several additions to our faculty.

Miss Peterson, instructor in the instrumental music department, is from Wisconsin. She is a graduate of the School of Music of Milwaukee, and has also attended State Normal School in Minnesota.

Miss Koller, instructor in the vocal department, is also from Wisconsin. She has attended the Winona Normal School in Minnesota and has received diplomas in voice, piano, and public school music from the New England Conservatory of Music. She has studied two years abroad and taught in the Manual Arts High School, Los Angeles. The last two years Miss Koller has had a studio in New York City.

Mr. Harris, who has taken Mr. Jay's place in the geography department, is from Illinois. He is a graduate of the University of Chicago; was superintendent of the Dewey Township High School, Indiana, and taught in Joliet High School in the geography department for four years.

Mr. Jay has taken Mr. Bassett's po-

Faculty Men Help the Farmers.

During the summer, some of our energetic faculty men helped various farmers in this vicinity with their harvesting. The money earned was donated to the Normal Junior Auxiliary Red Cross, and amounted to about $10. Those who showed their prowess in the field were Messrs. Jay, Ginnings, Hursh, Van Cleve, Schuppert, and Hollis.

---o---

sition as head of the Geography department.

Miss Lund, critic in the seventh grade, is from North Dakota. She has attended the Western State Normal at Hays, Kansas, University of Kansas, and University of Chicago. Miss Lund taught four years in the Agricultural School, North Dakota.

Miss Youngquist, fourth and fifth grade critic, is from Michigan. She is a graduate of the Ypsilanti (Mich.) State Normal School, and has studied at Madison University, Chicago University, Bay View, and State Normal at Hays, Kansas.

Miss Ruth Cochrane, instructor in the Country School department, graduated from this school in 1915. Miss Cochrane, who is from Good Hope, has been teaching in Moline and near Abingdon since graduation.

Miss Lundeen of Wataga, is assistant in the second grade.

Georgia Mullen, one of our own former students, has taken the place of Mrs. Jacobs in the office.

Miss Dallam has been given a leave of absence for one year to study music in Chicago.

Miss Alta Thompson is taking work at Columbia University and also teaching in the Horace Mann School, New York.

Mr. Bassett has entered the service of the government on the War Trade Board at Washington, D. C. He is investigating the trade of Chili, Peru, Bolivia, and Ecuador with this country. Mr. Bassett, who has bought a house in Washington and moved his family there, will probably remain for the duration of the war.

Mr. Green, formerly of the Manual Training department, is assistant superintendent in a factory at Argo. He is residing in Berwyn.

BACK IN SCHOOL ONCE MORE

NORMAL REOPENED MONDAY.

After five weeks of vacation due to the influenza epidemic, the Normal opened last Monday morning, Nov. 18, with a fairly good attendance. A number of doctors and nurses were on hand to give medical inspection, and in the first two hours all the students and faculty were examined and given certificates permitting them to enter school. A few who had symptoms of colds were sent home to stay for a few days.

Everyone seemed glad to get back to work, and the next five weeks promise to be busy ones. There will be few outside activities this quarter, but the main emphasis will be placed on finishing the term's work in satisfactory shape. In order to cover eight weeks' work in five, recitations will be at 8 a. m. and close at 4:15, thus thus giving hour instead of fifty-minute periods. The noon intermission will be from 12:00 to 1:15. School will continue on Saturday, and will close Friday, December 20, for a week's Christmas vacation.

The literary societies and Green Door will postpone their meetings until after Christmas, while the band will meet once a week, and the chorus every other week in the afternoon until the end of the quarter. Basketball practice will be limited this term to one afternoon a week, and the schedule games will not be played until after Christmas. Military drill will continue as usual.

By thus reducing the number of activities and placing them in the afternoon so that evenings may be free for study, the faculty hopes to make it possible for the students to complete their work without too great difficulty. The library will do its bit by remaining open till 5:45 in the afternoon.

It's up to each one of us now to see how much pep and enthusiasm we can put into the next five weeks' work and how many of us, despite handicaps, can go over the top December 20 with a goodly collection of A's and B's.

According to the *Western Courier* on November 22, 1918, WISNS reopened after it was temporarily shut down due to the great influenza epidemic of 1918.

In the spring of 1915, WISNS president Walter Piety Morgan's proposal for a new arts building passed through the Illinois legislature. Opening in 1918 and constructed at a cost of $135,000, the arts building provided immediate classroom and socializing relief space for the crowded Sherman Hall building located next door. The arts building was designed to complement Sherman Hall, and the two buildings were connected by a covered walkway. The arts building housed numerous departments, including household arts and domestic sciences. In 1968, the arts building was renamed in honor of beloved English professor Irving Garwood.

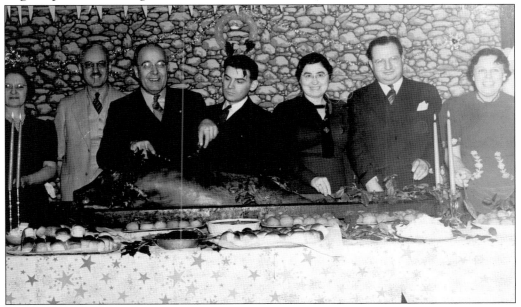

Dr. Irving Garwood, professor of English, carves a pig at his annual Christmas party.

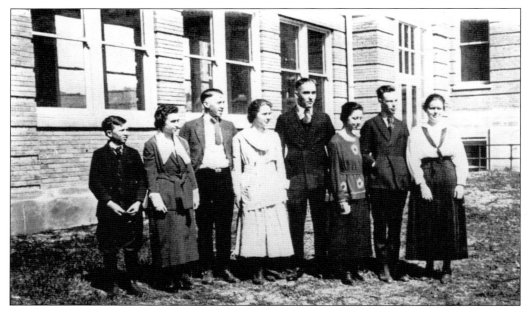

In 1918, WISNS president Walter Piety Morgan created WISNS's first student council, with representatives from both the laboratory school and the college. Before they had the right to vote in the United States, females were elected to student council positions, demonstrating WISNS's commitment to progressivism. The inaugural student council met on a monthly basis and tackled topics ranging from disciplinary problems to ways to raise funds for the Roosevelt Memorial Fund.

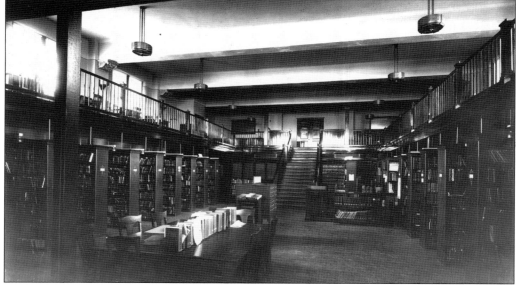

Colleges and universities often brag about the quality of their libraries. In the 1920s, the library at WISTC was cramped and insufficient for the growing school. In the late 1920s, WISTC received funds to renovate the previous gymnasium to a library. The result is this attractive library, with space for periodicals, book stacks, card catalogs, and a reading room.

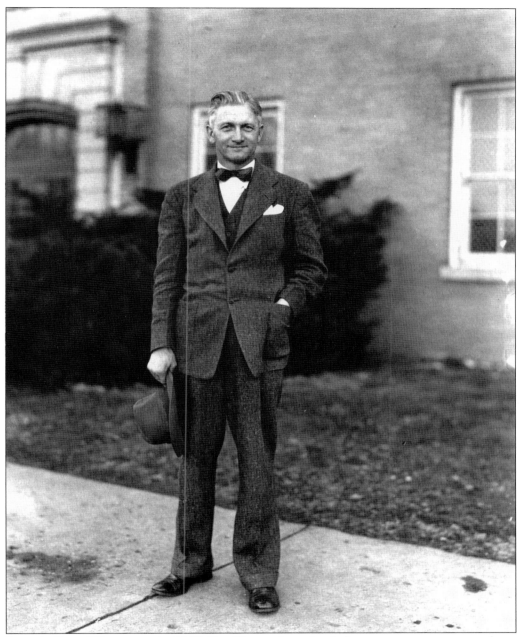

Born in Vasa, Minnesota, in 1885, Ray Hanson's aptitude for sports was apparent from a very early age. When America entered World War I, Hanson enlisted in the marines and by the war's end had received the Navy Cross, a Silver Star, and a Purple Heart. After college, Hanson studied under Knute Rockne at Notre Dame, and it was Rockne's recommendation that earned Hanson the job as head coach at WISTC in 1926. Hanson reenlisted in the marine corps during World War II where he achieved the rank of lieutenant colonel before returning to WISTC to serve as athletic director and head of the men's physical education department.

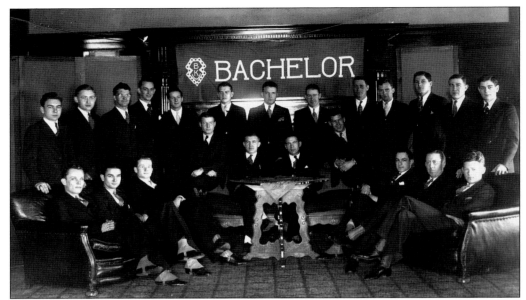

Social clubs have long been a part of the WIU student experience. In 1924, campus men organized the Bachelors' Klub. It sought to promote good fellowship, social activity, and loyalty at WISTC. Membership was exclusive, with only 10 men from each of the sophomore, junior, and senior classes allowed at one time. Dances, sponsored in cooperation with the women's Diana Klub, were a social highlight. The Bachelors' Klub reached its peak in the 1930s and 1940s and gradually faded after fraternities were introduced to WISTC.

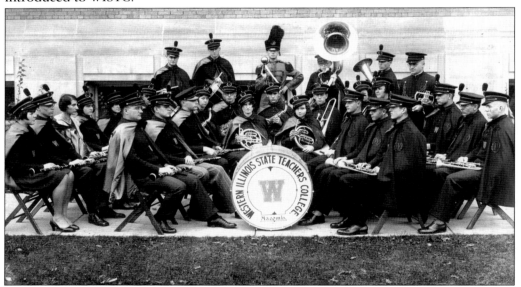

Under the leadership of the talented Walter H. Eller, who penned WISTC's fight song, "We're Marching On," WISTC's marching band had grown to over 25 members strong in this 1930s-era photograph. The band wore elaborate purple and gold uniforms and performed for many campus and community events, including football games, special concerts, and an Armistice Day program.

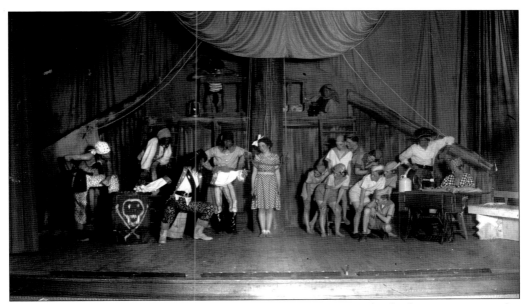

In the days before television, live theater was a popular method of entertainment for young and old alike. In this 1933 photograph from Western Academy, students put on a rousing rendition of the popular J. M. Barrie play *Peter Pan*, "the boy who wouldn't grow up." Western Academy's production included the Lost Boys, Captain Hook, Wendy, and the other beloved characters.

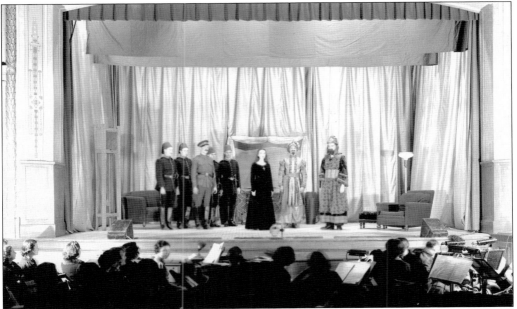

A scene from *The House of Ramah* performed during the 1938 theater season at WISTC featured student actors, lavish set designs, and a full orchestra. The play transported audiences to Jerusalem on December 19, 1917, and the city's capture by English field marshal Edmund Allenby from the Ottoman Empire. Maurice Arnold, a Macomb native (third from left), played the British marshal Allenby in this production.

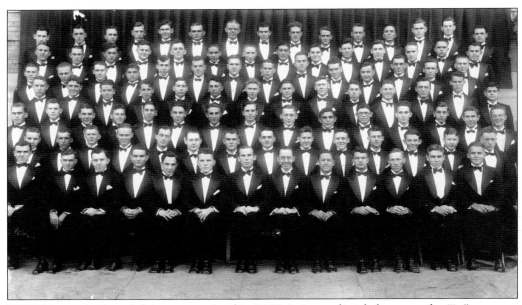

WISTC's men's glee club was organized in 1929. It immediately became the "in" campus music group, growing from 40 singers to a 100 in just a few years. The glee club was frequently on the road, performing concerts throughout Illinois and neighboring states. It became so popular that Chicago radio stations booked the group for concerts in a time when radio was the only way to access large audiences. As the picture shows, the glee club traveled in its own festive, distinctive buses and dressed sharply in black tuxedos and bow ties and bright white shirts.

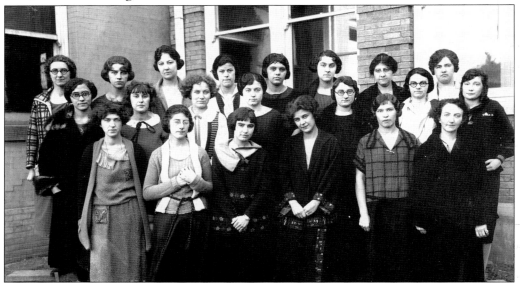

The MacDowell Glee Club debuted in 1923. It was one of several vocal music groups on campus. The MacDowell Glee Club was composed of female students who were concentrating on musical studies at WISTC. They sang a variety of choral favorites, often to the joy of their audiences. The group remained popular throughout the 1940s, 1950s, and 1960s under the quality direction of Dr. Forrest Wanninger.

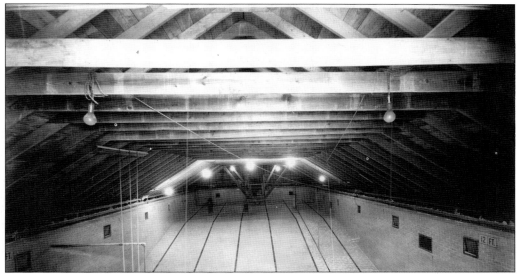

Weather conditions during the winter of 1936–1937 were so harsh that a make-shift roof was created to shield workers from the elements as they raced to complete the swimming pool behind Morgan Gymnasium. Early swimmers were required to wear suits approved and provided by the college and have a physical examination before using the facility. In 1951, a super structure enclosed the original open-air pool at a cost of $104,300, allowing students and faculty to use and enjoy year-round. The pool survived the 1970 Brophy Hall fire, but it is no longer in existence.

The fourth instructional building on campus was completed in May 1928 and named after WISTC president Walter Piety Morgan. Morgan Gymnasium's exterior was constructed of gray brick. Its interior was bathed in natural light from several large windows. From its beginning, the gymnasium was the center of WISTC's social and athletic life. Morgan Gymnasium hosted indoor sporting events, homecoming dances, commencement ceremonies, and even former First Lady Eleanor Roosevelt, who visited WIU in the 1960s for a speaking engagement.

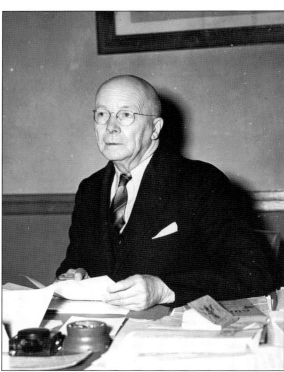

Here is Dr. Rupert R. Simpkins, director of the Western Laboratory School.

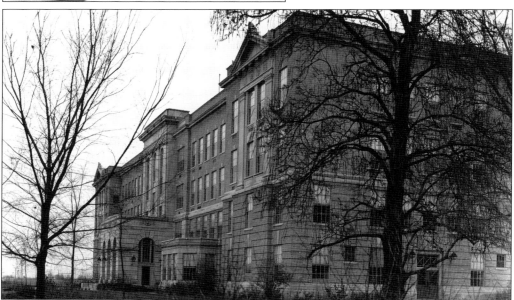

One of WIU's most historic and attractive buildings is Simpkins Hall, located just west of Sherman Hall. Rupert R. Simpkins, hired by school president Walter Piety Morgan as director of the training school, long dreamed of a modern facility for the laboratory school. It was not until the building opened in 1939 that it was realized. Simpkins Hall served the laboratory school until it moved to Horrabin Hall in 1968. Today Simpkins Hall houses the Department of English and Journalism.

Western Loyalty

Words by Walter P. Morgan
additional verse by Kathy Cavins and Tim Krug

Music by Harold F. Shory
ed. James Caldwell, 1994

In 1930, Morgan penned the words to what would become WIU's most famous musical rallying cry, the song "Western Loyalty." Set to a tune by Harold F. Shory, "Western Loyalty" is a beautiful tribute to the school and the lasting impact WIU has on its students. In 1994, the song was made more contemporary with the assistance of Kathy Cavins, Tim Krug, and James Caldwell. "Western Loyalty" remains popular with the WIU community nearly 80 years after it was written.

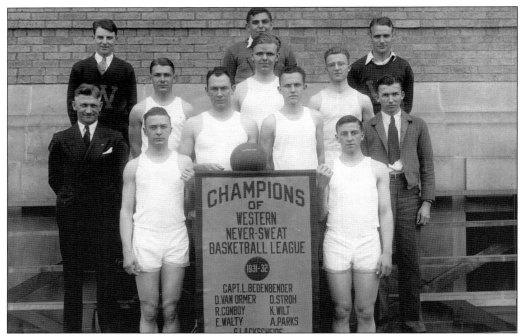

Created by Dr. James Naismith in 1891, basketball became a popular game on college campuses by the 1930s. Western Never-Sweat Basketball League was designed for young men to develop their skills as they participated in tournament-style competition. Intramurals gave students the opportunity to participate in athletics without the full-time commitment of a varsity sport.

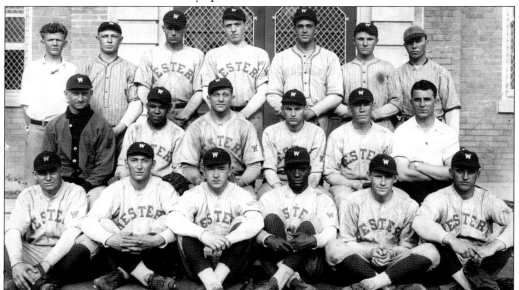

WISTC's baseball team fielded two African American players during the 1929 season. In an era when a man's color was more important than his ability, coach Ray Hanson believed the opposite. WIU athletics have enjoyed a long tradition of embracing student diversity on and off the playing fields.

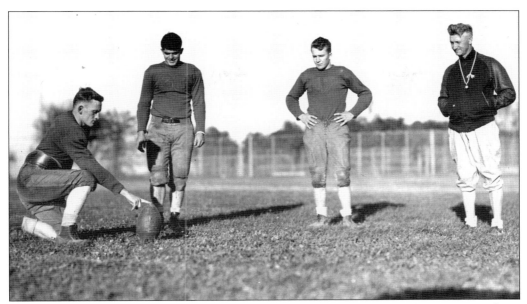

Early football uniforms were minimal in appearance and provided little protection from serious bodily injury. Although not as utilized as today, the kicking game in 1930s college football proved to be an effective tool. Above, Wink Harris holds the ball as Ed Gallasse prepares for punting practice. Bob Bricker and coach Ray Hanson observe the two.

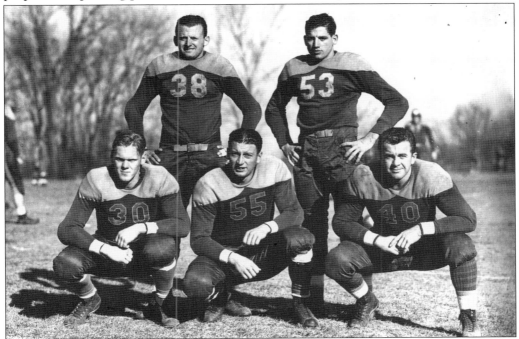

Loren Jenks (38), Eldon Atwood (53), Warren Page (30), Curt Lockhard (55), and Jack Harn (40) pose for this picture at the start of their 1940–1941 senior season. All five were part of the previous year's championship squad, returning for their last year of college football.

A tradition during the Walter Piety Morgan years was for the faculty to assemble each year for a group photograph. This image from the years immediately preceding World War II shows Morgan's group. President Morgan is standing front and center in the black suit. Frederick Currens is standing to Morgan's left; Rupert Simpkins is to his right.

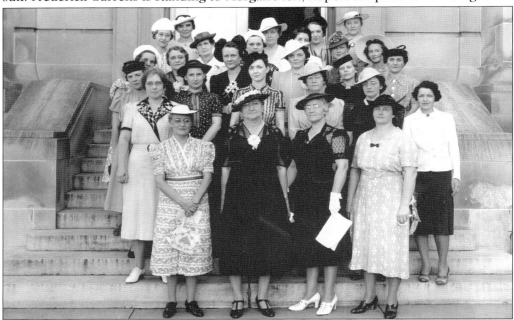

The faculty wives formed a strong female network on campus, and especially in the Macomb community. The women gathered both formally and informally to discuss matters, complete service projects, and just to socialize. Pictured here are many faculty wives, including Mrs. Frederick Currens (first row, left), Mrs. Walter Morgan (first row, second from left), Katherine Sallee (first row, far right), Mrs. Harry Waggoner (second row, fifth from left), and Mrs. Wayne Wetzel (top row, far left.).

Three

BEU
1942–1957

Perhaps no WIU president elicits more passionate comments, favorable or otherwise, from faculty and students than Frank A. Beu. His tenure saw unprecedented growth on the WISTC campus and a period of great change in higher education policies nationwide. All this contributed to making Beu's 15 years as president a pivotal period in WIU's history.

President Beu took the reins of WISTC in 1942. The nation was at war, and the campus was mostly populated by women. Those who remained in Macomb contributed to the war effort by volunteering at the USO in town, knitting clothes, and conserving and rationing foodstuffs. Women also trained in nursing and office tasks like typing, skills the country needed desperately.

In 1944, Congress passed the Serviceman's Readjustment Act, commonly called the G.I. Bill, to provide educational and housing benefits to World War II veterans. This influx of federal dollars had a revolutionary impact on colleges nationwide, including WISTC. Enrollment began growing as early as 1945, and the growth was astounding. In 1945, WISTC enrolled 1,200 students. By 1956, this number had more than doubled to 2,500.

With an exploding student population, Beu had to act fast to build WISTC's infrastructure to handle the influx. Buildings popped up seemingly overnight, and the physical campus took on the basic look it has now. Facilities added during the Beu period include Tillman Hall, Hanson Field, and Seal Hall. Countless faculty members were hired too in disciplines across campus. It was this faculty that stayed with WIU into the 1970s and 1980s and put WIU on the map as a quality university.

The Beu era at WIU ended with a sudden thud. Several faculty members were displeased with the emphasis Beu placed on WIU athletics and how Beu handled some off-campus problems involving athletes. After a media storm and threats from WIU's accreditation body, Beu resigned in early 1958.

The 1940s and 1950s were a whirlwind period at WIU. Enrollments numbered in the multiple thousands, buildings were constructed everywhere, many new employees were added, and WIU became a university. Frank Beu's 15 years at WIU's helm was a pivotal period in the school's history, and his leadership prepared the school for the challenges of the turbulent 1960s.

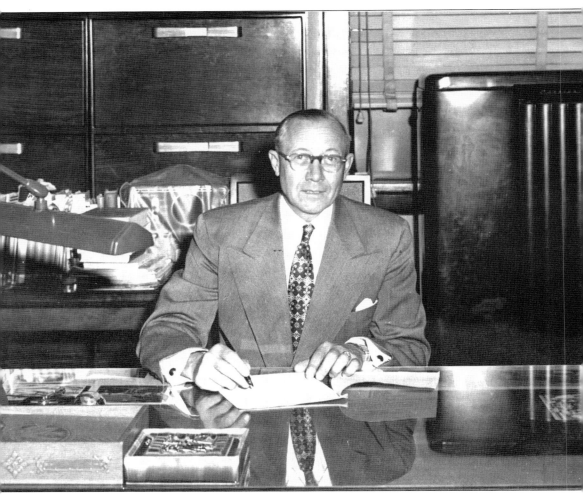

Frank A. Beu was born in Huntley in 1897. An exceptionally gifted student, Beu earned his bachelor's degree in social sciences and English from Northwestern University in 1920. He remained in Evanston and earned a master's degree in education three years later. In 1936, Beu earned a doctorate in education from the University of Chicago. Dr. Beu was named WISTC's fourth president in 1942. Beu oversaw a period of exceptional growth at WISTC, including the initial offering of graduate courses and the school's 1957 transformation to a university. Dr. Beu retired from office in 1958.

School spirit has never been in short supply at WIU, and this student is ready to cheer the Leatherneck team to victory. While the cheerleaders of today use acrobatic feats to fire up the crowd, only a trusty megaphone and a shiny outfit were utilized by pep leaders of yesteryear.

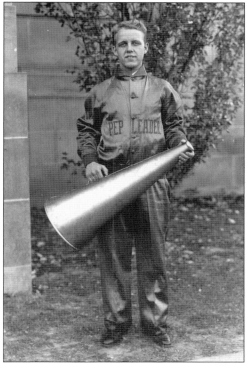

The stately English Colonial home on the southwest corner of Adams and Ward Streets was bought in 1940 from Mrs. Henry Zahern, wife of the home's original owner. The home economics department used the property as a training laboratory and residence facility for students for the next 33 years. The alumni association moved its operations to the building in 1978 when home economics no longer required the property for its instruction. A late 1979 fire and the resulting $90,000 renovation closed the house until 1982. Since reopening, many alumni return every year to visit the house during homecoming and other campus events.

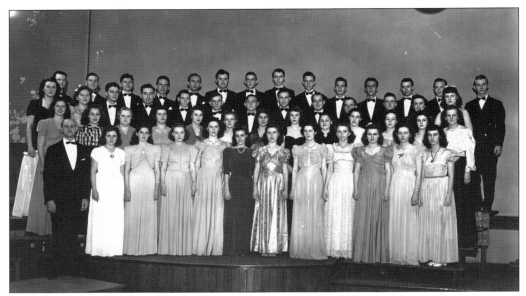

One of WIU's most recognizable choral groups is the mixed chorus. Membership consisted of 50 members chosen each fall from the men's glee club and the MacDowell (women's) Glee Club. In this 1942 picture, the mixed chorus, under the direction of Carl Nelson, performs at one of several campus concerts during the academic year. The group also went on the road in April, with performances in Knox, Stark, and Henry Counties, before a final appearance in Chicago.

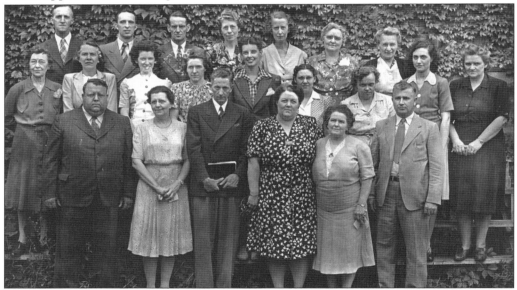

This image, which first appeared in the 1946 *Sequel*, is of the graduate club. President Frank A. Beu recommended WISTC organize a graduate club in 1944 as a social and educational outlet for the school's new graduate students. Twenty-four students were club charter members. Arthur Tillman was the first faculty sponsor for the group, which held numerous activities throughout the year, including musical programs, faculty receptions, and so-called "talk-fests" in the students' lounge.

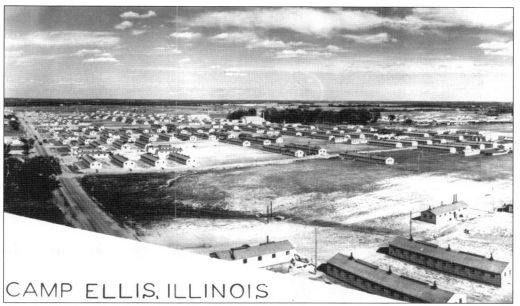

CAMP ELLIS, ILLINOIS

Camp Ellis, a World War II–era army training center and prisoner of war camp, was located just west of Macomb in Fulton County. During the war, many soldiers came into Macomb to relax and mingle with WISTC students at the USO or to do some light shopping. After the war, Camp Ellis returned to farmland, but some of the soldiers and workers at camp continued their education at WISTC.

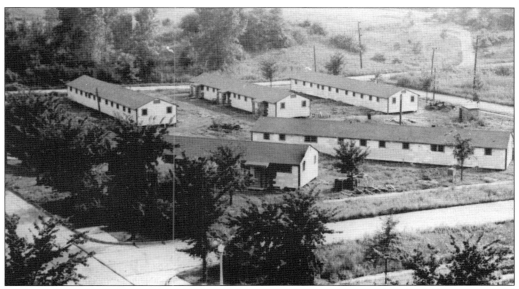

Growth on the WISTC campus was explosive in the years immediately following World War II, as veteran students took advantage of their G.I. Bill educational benefits to enroll at the school. Housing was in short supply for the veteran students, many of whom were married with families. The housing crunch was temporarily alleviated by the acquisition and relocation of former military barracks. These barracks were moved from Michigan.

Tributes Commemorate V-E Day

School Observes End of European War Quietly

The Western Courier

VOLUME 42. MACOMB, ILLINOIS, MAY 9, 1945. NUMBER 27

Planned by Western's War Council some months in advance, the special program in observance of V-E Day was presented yesterday morning following the regular assembly program. Prof. Carl Nelson led the audience in patriotic songs. Prof. Karl Crilly accompanied the numbers on the piano and organ.

Officers Usher.

Retiring members and officerselect of the WAWS council who served as ushers were Dorothy Ann Loring, Patricia Ball, Jeanne Wetzel, Helen Sowder, and Catherine Bauner.

The Reverend Leslie Whitcomb of the Macomb Presbyterian church gave the invocation and benediction. Members of the student body who have served in the armed forces in World War II were seated on the stage during the program.

In describing what V-E day means to the serviceman, Bob Blaha said that he would be thinking of the little things which meant home and America to him. The fighting man in the Pacific, he stressed, did not dare make today a holiday for to do so might mean death.

Stay On Job

President F. A. Beu pointed out in his address that rationing and other restrictions will not be relaxed immediately and that we should not expect this. As long as Japan is to be beaten, we should stay on the job, he feels.

The program presented was as follows:

Pomp and CircumstanceThe Pipe Organ
Assembly Call Trumpets Misses June Chilberg and Mary Sneeden
Invocation Rev. Leslie Whitcomb
The Star Spangled BannerAudience
What V-E Day Means to the Service Man Mr. Robert Blaha
Songs of the Allied NationsAudience
What V-E Day Should Mean to the CivilianDr. Frank A. Beu
America The BeautifulAudience
Our Gold Star Men Miss Alice Jones
Pipe Organ Accompaniment
There Is No Death O'Hara Miss Lavona Johnson
BenedictionRev. Leslie Whitcomb
Organ PostludeThe Pipe Organ

Beighey Writes Text Book

Dr. D. Clyde Beighey, along with his co-authors, William Polishook and Howard Wheland have had published their new book, "Elements of General Business."

The book is an unusual, teachable chapter organization and brings the business world to the student through his own experiences as a student and through his interests as a future citizen.

Mr. Polishook is head of the department of commerce at East Orange high school, East Orange, N. J.; Mr. Wheland is head of the commercial department at the John Hay high school, Cleveland, O., and Dr. Beighey is head of the commercial department at Western.

Green Door Has Banquet At Lamoine Monday

The annual Green Door banquet will be held May 14, 6:30 p. m. at the Lamoine hotel. Committees in charge are: arrangements, Virginia Hankins, Sarah Cunningham; decorations, Martha Traser, Maxine Smith, Betty Jane Neuhaus, La Vona Johnson; program, Alice Jones, Norma Robeson, Jody Smith.

To Direct "Music For Victory"

Prof. Carl Nelson

Prof. Floyd Ohlson

The Faculty Men's chorus, the MacDowell Glee club, and Western college orchestra will present a joint concert in the auditorium, Thursday, May 10th at 8 p. m. The title of the program to be given is "Music For Victory Concert." The following numbers will be heard.

Overture, "The Shepherd King"Mozart
Song of the Bayou Bloom
Song of the Flame ... Gershwin Russian Sailor's Dance .. Gliere Western Orchestra, Floyd Ohlson, Conducting
The Blind PloughmanClarke
Hymn to a HeroTom and Fred Waring MacDowell Glee Club. Carl Nelson, Conducting
John Peel Andrews Love's Old Sweet Song .. Mallov Jolly Fellows Rhys-Herbert Western Faculty Men's Glee Club, Carl Nelson, Conducting
Night and Day Porter Great Day Youmans MacDowell Glee Club A Little Close Harmony . O'Hara Those Pals of OursGreaton-Cole Stout Hearted Men Romberg Western Faculty Men's Glee Club
Ode to America Cain Chorus and Orchestra, Floyd Ohlson, Conductor

The entire proceeds of the concert are to go to the Scholarship Fund. Tickets will be on sale in lower hall and lounge and Dumsworth and Miner's Book stores and Scheyler's Music store.

This also is a debut to the faculty men's cause and the members of this new organization are:
Tenors — Courtney Aldrich, Charles Lindell, Harvey Seal.
Second tenor — Marcv Bodine, Roscoe Linder, Clifford Pearce.
Baritone—Floyd Ohlson, Louis Schleier, Moses Thisted.
Basses — Lee Heintz, Charles Outhout, James Shultz, Harry Waggoner.

Tom Ward Killed At Fort Riley On Easter

"Tommy always looked forward to going back to Western to finish college when the war was over but now he can't," his wife writes Dean Min..................Tom Ward was a student here in 1941-42. He left after that year, joining the army as an MP. He was married last December while stationed at Ft. Riley, Kan.

"Easter Sunday morning," she writes, "Tommy fell down the steps while carrying his .45. It went off and the bullet lodged in his brain. He was accorded a military funeral with full honors."

He visited Western last year while on furlough.

Outdoor Lunch, Tea, Variety Show Headline Guest Dav

Western's four social sororities are sponsoring a guest day Saturday at which time high school seniors from surrounding towns will visit our campus. Instructors are asked to be in their rooms from 10:30 till 12:30 when tours and conference are scheduled.

The COURIER has planned an exhibit showing the stages in a story's development before it is printed. Today's paper will be given the guests.

A special art exhibit will be held in A-20 and A-22 for guest day.

Dorothy Samuelson, Mildred Hamilton, Jean Switzer and Miss Theodora Pottle will be there to meet the guests.

In A-20 will be the work of the students during this quarter. It will be work on creative and commercial art. In A-22 will be the things to do for creative teachers from the interior decorations class will be shown.

The schedule for the day is given below:

10:00-10:30—Auditorium. Songs. Address by Dean Currens.
10:30-12:30—Tours. Conferences.
12:30-1:30 — Luncheon on the campus.
1:30—2:30 — Tour through Monroe Hall and Home Management House.
2:30—3:30—Variety Show.
3:30-4:00—Free Time
4:00-5:00—Tea—social room, arts building.

Prominent Alumus Speaks On Post-War Education

Dr. Harry K. Newburn, Western graduate of 1928, spoke to assembly Tuesday morning. Dr. Newburn is president-elect of the University of Oregon, and is at present dean of State University of Iowa.

In his address on "Education After the War," Dr. Newburn stated that better goals in education would be equally important for people of this country as they have been for people in Russia and Germany. The characteristics which have been most meaningful in our social structures have been the degree of flexibility, our aspiration for better things and our universal education system, according to Dr. Newburn.

There are such factors as the program for the armed services and the fact that we are facing the subsidy of education, affecting educational systems today, according to Dr. Newburn. He also said that the returned service man is another factor in the

(Continued on Page 3)

COURIER Wins First Class Honor Rating From A C P

The Associated Collegiate Press, with headquarters in the University of Minnesota, has given the Western COURIER a first class honor rating for the first half of this school year.

The COURIER was given 820 points in an evaluation of the following: news values and sources, news writing and editing, headlines, typography and makeup, department pages and special features. A score of 900 is required for All-American rating which is "superior." First class is designated as "excellent."

The dues which the COURIER pays as a member of the Associated Collegiate Press entitles it to a critical service, as well as to the use of ACP feature and editorial material which is received monthly.

War effort coverage was given an excellent designation in the score book, which gives many suggestions for improving each department of the paper.

The COURIER received a first class honor rating last year also.

Juniors Vote For '46 Sequel Editor Today

Election of 1945-46 Sequel editor and business manager is being held today. Every junior is urged to vote. Candidates are listed in the lower hall. The nominating committee was composed of officers of the junior class, Phyllis Schehl, president; Betty Huston, vice-president; Dorothy Reeve, secretary-treasurer and Dr. Hilda Watters, sponsor.

Mary Gross Heads Council. Officers Elected

Mary Gross was chosen as 1945-1946 student council president, and Gaylord Zimmerman, vice president in the election last Wednesday.

Mary is a junior from Clavton. A commercial major, she is active in Pi Kappa Sigma, Pi Omega, commercial club and student council.

Senior class officers for next year will be Magnolia Rawls, home economics major, president; Betty Huston, commercial major, vice president; Dorothy Reeve, home economics major, secretary-treasurer.

Maxine Reis, social science major, will head the new junior class. Marie Carlson and Myrna Johnson, commerce majors will serve as vice president and secretary-treasurer.

Next year's sophomores will be led by Colleen Myers. Peg Charlesworth, social science major, will serve as vice president. Pat Allen, home economics major was elected secretary-treasurer.

House Presidents club elected the following officers last week: Lois Hammond, president; Elva Cuba, vice president; Maxine Smith, secretary; Marie Birch, treasurer.

Dorothy Reeve has been elected president of the Monroe Hall girls organizations for next year. Jean Faulkner is vice president; Mildred Fornoff, secretary and Magnolia Rawls, treasurer.

Dr. Arthur TerKeurst has been

Dr. Arthur TerKeurst has been appointed dean of men at Southern Illinois Normal university. He takes office in September.

Dr. TerKeurst has been at Western since 1940, having been dean of men four years and dean of general college the past year.

WAWS Plans ——

Traditions To Be Carried On
—— Next Year

"Traditions of the WAWS Council will be carried on next year," stated Pat Ball as she was installed as president of WAWS Monday evening.

The annual WAWS formal installation banquet was held at the Lamoine hotel, with thirty members present. "Reaching For the Stars" was the general theme for the banquet, and the table decorations and short speeches were in keeping. Past-president Dorothy Ann Loring introduced the new officers and they were installed by the officer whose place they are taking.

"Star gazing," was the theme of the retiring president's speech. Dorothy Ann reviewed the numerous activities that the WAWS has sponsored during the past year. They include such things as the orientation and big-little-sister program for freshman girls in the fall, music appreciation meetings, after game dances, the all school Christmas party, and the traditional "Women's Week." The Council has helped the various clubs represented with their problems. Pat Ball in "Reaching

for the Stars" expressed the desire to continue the policy with WAWS council much as it has been this year and that to reach every girl in school will be again the aim of the Council.

Helen Sowder, past and future vice-president of the council expressed a few remarks on "Lingering Light." Dean Minna Hansen, as the sponsor of the organization completed the program with a talk on "Twinkling Light."

Mrs. Floyd Ohlson was introduced as one of the sponsors for next year. Mrs. Carl Nelson will serve another year as sponsor. The council is made up of Pat Ball, president; Helen Sowder, vice president; Catherine Bauner, secretary; Jeanne Wetzel, treasurer; Magnolia Rawls, Home Ec club; Eloise McNall, YWCA; La Vona Johnson, MacDowell Glee club; Patty Tiernan, Pi Kappa Sigma; Helen Sowder, Alpha Sigma Alpha; Barbara McDowell, Delta Pi Lambda; Jean Switzer, Chi Phi Sigma; Betty Alice Miller, WAA; Kathryn Lahan, PE majors; Mary Gross, Student council; Betty Alice Miller and Phyllis Schell, orientation.

Here is the *Western Courier*, May 9, 1945, coverage of VE Day, symbolizing Allied victory in Europe.

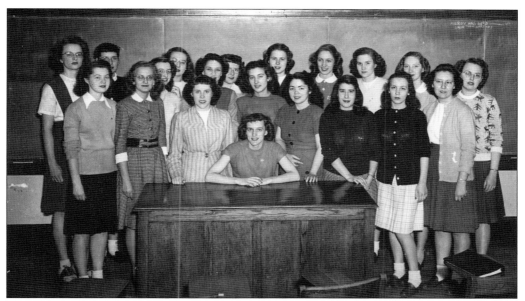

Begun to promote social and professional growth and unity for kindergarten through primary school majors, the Western Association for Childhood Education boasted a mission to improve the educational opportunities for young children. One of its most celebrated annual activities was the story-telling project. Each member of the association would read stories to children at local orphanages. The group worked closely with the Western Illinois Laboratory School in addition to area elementary schools.

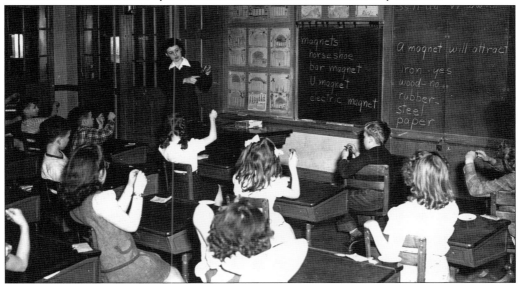

As a normal school, or teachers college, WISTC operated its own training school so its students would have a place to practice what they were learning in the classroom. The training school was located for many years in the four-story Simpkins Hall. When the training school moved to a modern building and college classes moved in to Simpkins, students and teachers alike were frustrated by the chalkboards and other amenities built for small children.

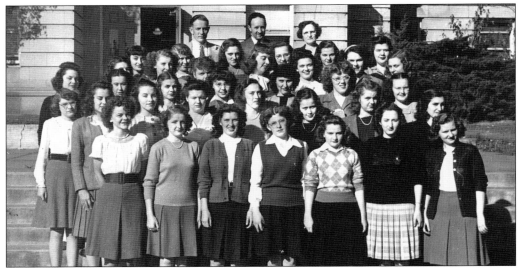

The Canterbury Club was another campus organization for students to gather informally around a shared interest. In this case, it was English. The Canterbury Club sponsored original and interpretive creative work and furthered literary development. The organization was divided into two subgroups, the Emersonians and the Platonians. Highlights of the year included an autumn frolic, an annual literary contest, and a May breakfast. In this 1947 picture, members of the Canterbury Club pose with their faculty advisor Dr. Robert Smiley (back row, center).

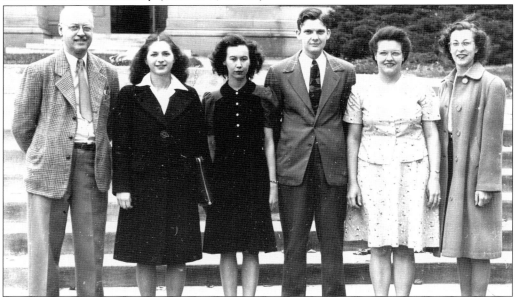

Alpha Delta was a national honorary society for journalism. At Western, Alpha Delta sought to strengthen an interest in quality journalism, market the university, encourage good will between alumni and students, and improve the *Western Courier*. In this picture from 1947, five WISTC students are pictured with faculty sponsor Dr. Kent Pease (left). The national Alpha Delta merged with another journalism society, Alpha Phi Gamma, in 1957.

The years immediately following World War II were marked by great growth at the school. The greatest growth was found in the school's general college, which prepared students for fields other than teaching. Recognizing this growth, the teachers college board renamed WISTC Western Illinois State College in 1947. The growth continued in the early 1950s, and by the end of that decade the state college name was again obsolete. In 1957, the school's name was changed to its present name, WIU, reflecting the school's expanded academic programs.

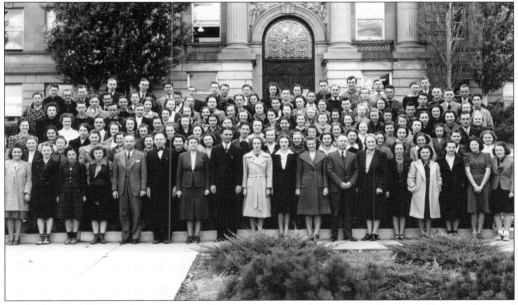

In the late 1940s, student organizations were a regular campus feature. Groups formed for social and professional purposes to apply knowledge learned in the classroom. The Commercial Club was one of these groups. The club represented the largest group on campus, and it acted as an extension of the business classes being taught at WISTC. The coed Commercial Club initiated new members each fall.

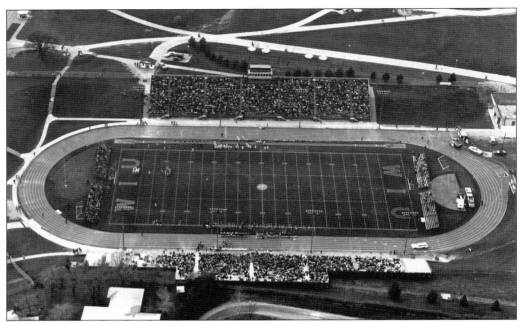

Named for WISC's football, basketball, baseball coach and athletic director Ray "Rock" Hanson, Hanson Field was dedicated in 1950. The stadium drew a capacity 5,000-spectator crowd during its inaugural game when thousands of fans watched as the Fighting Leathernecks claimed victory against the visiting Central Michigan College Chippewas by the score of 28-7.

Established as a way to improve campus moral, promote higher academic standards for varsity athletes, and proudly represent the "W" insignia, the WISTC Varsity Club began in February 1928 with the aim to stimulate better athletics through scholarship and citizenship. Throughout its history the varsity club continued to be a leading force on campus.

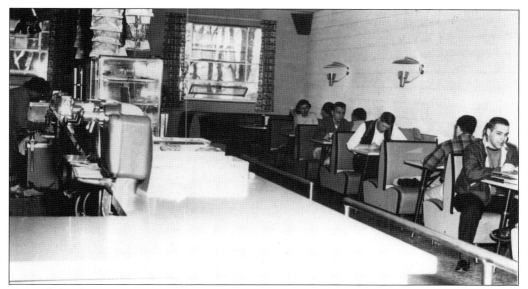

One of the favorite campus hangouts in the 1950s and 1960s was the student center, located between the Bennett and Hursh residence halls. The student center featured many amenities of home, including a fireplace, game room, television, and patio. Another favorite feature was the Leatherneck Nook, pictured here, where students could get a soda, chips, and other quick snacks throughout the day.

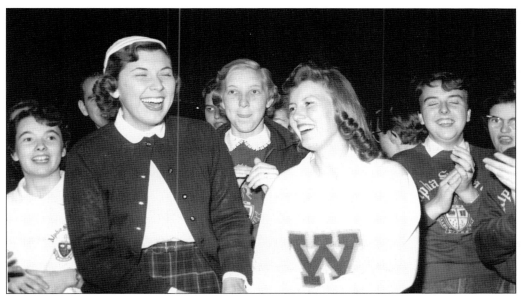

By 1943, the Western Academy was renamed Western High School and continued the rich traditions of academic excellence. Western High School served dual roles as a top area high school and as a teacher training facility for secondary education majors at WISTC. In addition to a superior academic experience, athletic competitions between Western High School and cross-town rivals Macomb High School allowed students to display school spirit at pep rallies and games. Western High School graduated its last senior class in 1973.

Here is professor of biology
Dr. Mary Bennett.

Located in the southeastern corner of campus, Bennett and Hursh Halls were built in the late 1950s, and they were ready for the influx of students who arrived on campus in the 1960s. One of the complex's trademarks was the large recreation room located between the two buildings, complete with a fireplace, television, and snack bar. Both dormitories were closed to student use in 1993. Hursh was torn down in 1998, Bennett in 2002.

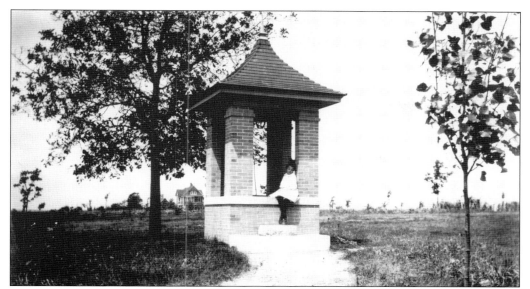

Before WISNS was founded, some of the lands occupied by the school were used as a brickyard. Located on the land northwest of Sherman Hall was a well that served the brickyard. It dodged demolition when the school was built, and the wishing well became a popular place for students and community members to meet and relax. The wishing well finally met its demise in the mid-1950s, when it was torn down to make room for Tillman Hall.

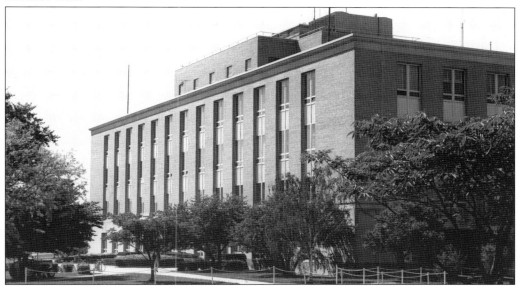

Constructed in less than one year, Tillman Hall's completion in 1955 was a welcome and much-needed addition to WISC's campus. Dedicated to former Department of Geography chairperson Arthur Tillman on September 17, 1955, the building currently is used by the geography and geology departments and the geology museum. Specialized weather instruments occupy space on Tillman's roof and collect vital information that is used for the study of meteorology. Its construction did require the old wishing well, a familiar campus fixture, to be removed so that Tillman's foundation could be built.

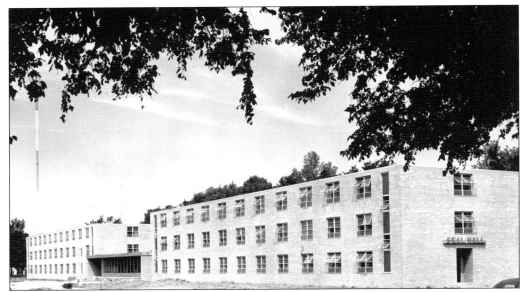

Named for Spanish-American War veteran and history professor Harvey Seal, Seal Hall was completed in 1955 and welcomed 204 male students. The building's two residential wings were connected in the center by a large student lounge. This collaborative space cemented the residents' feelings of unity that would define Seal. Tragically, the 1972 shooting death of freshman Steven Hyde interrupted that harmony. Today Seal Hall no longer houses students. Rather it is home to many campus offices, including disability support services, the women's center, and student development and orientation.

Many of WIU's students come to campus from rural Illinois, and they aspire to return to their rural homes after graduation to work in agriculture. During the 1950s, one way students gained more experience with the business side of agriculture and built friendships was to live in Rustic Lodge, an agricultural cooperative affiliated with the agriculture club. In this photograph, the men of the agricultural cooperative pose outside Rustic Lodge, located on the land currently occupied by Knoblauch Hall.

Four

KNOBLAUCH AND BERNHARD
1958–1973

Presidents Arthur L. Knoblauch and John T. Bernhard built on the work begun by Frank A. Beu. The campus continued to grow during this period, and external societal challenges placed on higher education were created by the values of the emerging baby boomer generation and the war in Vietnam. The country was changing, and WIU had to follow suit.

President Arthur L. Knoblauch arrived on campus in the fall of 1958. WIU was continuing its unprecedented growth, and Knoblauch was the right leader to do it. He had extensive experience with building projects, and this knowledge was put to good use as WIU's chief executive. During his presidency, WIU's enrollment jumped from under 3,000 students to nearly 10,000 students. To accommodate this huge influx of students, Knoblauch secured funding for over 20 campus buildings, many of them residence halls for housing the thousands of new students. Building construction overseen by Knoblauch included Browne Hall, Memorial Library, the university union, and Sallee Hall.

Shared faculty-administrative governance in decision making was becoming a hot topic in American higher education in the mid-1960s. Many WIU faculty members supported it; Knoblauch was less enthused. After a series of public and private meetings about Knoblauch's future, he quietly resigned from WIU, effective in 1968.

John T. Bernhard became WIU's president later in 1968. His administration is best remembered for its response to the Vietnam War, the civil rights movement, and the new personal freedoms college students demanded. Bernhard gave the students a great deal of freedom to protest the war and other social ills. The Brooks Cultural Center opened to promote African American culture, and WIU opened an office of affirmative action.

Budget problems plagued WIU throughout the 1970s. The most significant victim of the bad economy was Western High School, in 1973. A part of WISNS since its founding, the high school served the community well for 70 years before closing its doors. After a relatively short six-year presidential tenure, university president Bernhard left Macomb in 1974 for Western Michigan University.

The years 1958 to 1973 were a fascinating time to be at WIU. Enrollments were up drastically, new buildings were abundant, countless new faculty and administrators brought fresh ideas to campus, students became more active politically, and faculty played a bigger role in governing the university. Campus life had changed, and it was never going back.

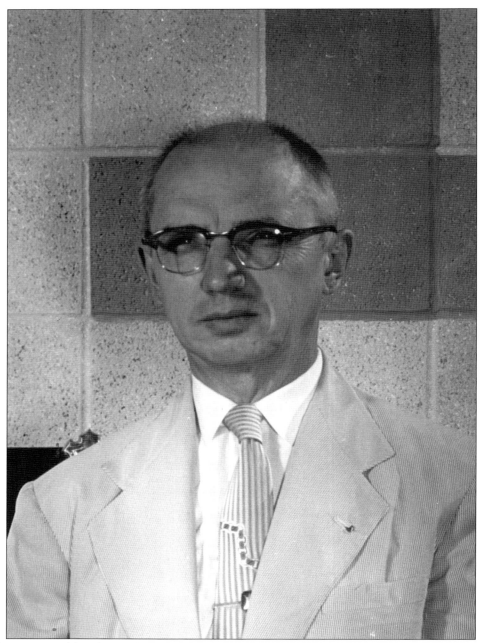

Albert L. Knoblauch was born in Riga, Michigan, in 1906. In 1929, he graduated with highest honors from Michigan State University, after working as a railroad laborer to afford tuition. He earned a master's degree from the University of Michigan in 1933 and a doctorate from Harvard University in 1942. He was named WIU's fifth president in 1958. Knoblauch helped guide WIU through a period of great growth, but his conservative views were often in conflict with the social climate on campus during the 1960s. During his presidency, Knoblauch oversaw over $53 million in capital development. He retired in 1968.

50

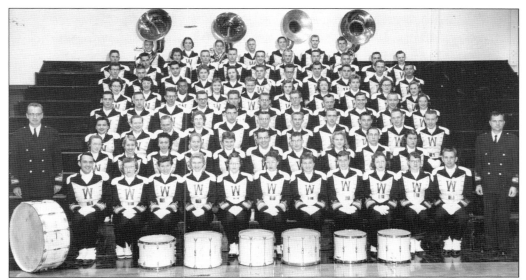

By the 1950s, the WIU marching band had grown to over 80 members. It continued its long tradition of providing quality entertainment during football games, parades, concerts, the annual spring tour, and other special performances throughout the community and region. This picture, from the 1958–1959 school year, shows the band donning classic marching band uniforms under the direction of Dr. Forrest Suycott Jr.

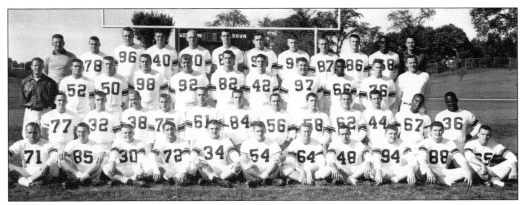

Under head coach Lou Saban, the 1959 Fighting Leatherneck football team completed WIU's first undefeated, untied season in modern school history. The nine-game season produced two shutouts and a thrilling homecoming game that saw WIU defeat Southern Illinois University 33-6. That same year the team also won the Illinois Intercollegiate Athletic Conference championship. In 1988, the 1959 team was the first in school history to be inducted into the Western Illinois Athletic Hall of Fame.

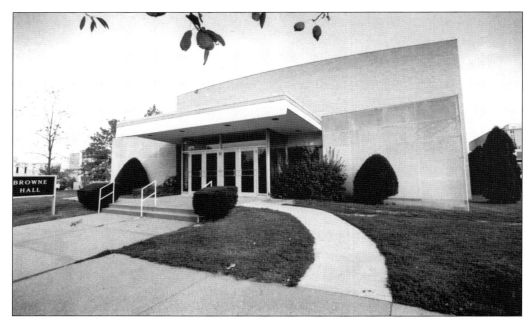

Named after former acting president Richard G. Browne, the fine arts building opened to the public in the summer of 1959. Originally designed to house the art, music, and speech communication departments, today Browne Hall is home to the School of Music and the Department of Theatre and Dance.

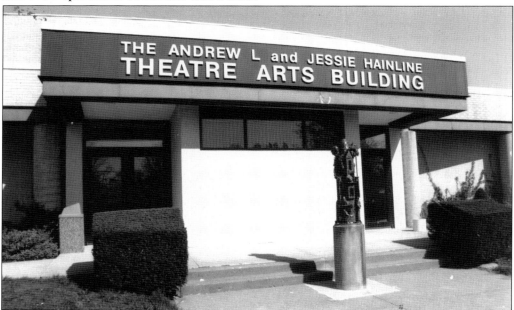

One of Browne's distinguishing characteristics is its nearly 400-seat proscenium Hainline Theatre, named in honor of former *Macomb Journal* owner Andrew L. Hainline and his wife Jessie Hainline. Hainline is currently the premier performance facility on the WIU campus, pending the construction of the long-awaited proposed performing arts center.

Over the years, WIU has had the great pleasure of welcoming a number of famous entertainers, politicians, and other notable personalities to campus. Famous singers and comedians to come to Macomb include Red Skelton, Johnny Cash, Elvis Costello, the Beach Boys, Ray Charles, Bill Cosby, and Jay Leno. Politicians who came to campus to shake hands include Ronald Reagan, Gov. Jim Thompson, Gov. Jim Edgar, and Sen. Paul Simon (pictured here). Many campus visitors enjoyed their stays in Macomb greatly. Red Skelton was so taken by the community that he donated a clown painting he had made to the university art gallery.

Eleanor Roosevelt visited the WIU campus on May 4, 1960, to deliver a lecture and tour the campus. The former first lady and United Nations diplomat delighted an engaged audience in Morgan Gymnasium as she spoke about her long and distinguished career in public service in a speech titled "Is America Facing World Leadership?" She chose to come to WIU because she found midwestern students a particularly good audience for her message.

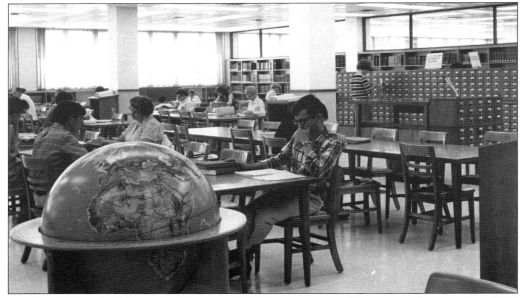

By the 1960s, the library in Sherman Hall was too small to serve the growing WIU community. At that time, ground was broken on a larger library with room for 200,000 books, additional periodicals, and an expanded reading room. In 1961, Memorial Library opened its doors. Shown here is the library's reading room, with study tables, and the card catalog cabinets. Memorial Library was the first campus library to have open retrieval book stacks and the Library of Congress classification system, rather than the Dewey decimal system.

Constructed in the height of the cold war, the foreboding and windowless structure on Murray Street, across from the university union, was known simply as the classroom building at its dedication in 1964. The lack of windows was specific and designed to protect occupants from radiation caused from nuclear fallout. Later the building was officially named for longtime biology professor Roy Sallee. Built at a cost of $1.1 million, Sallee Hall contains 42 classrooms and 27 faculty offices, including the Departments of Communication and Broadcasting.

On Friday, February 7, 1964, against the backdrop of a capacity crowd, Leatherneck guard Coleman Carrodine achieved basketball glory when he scored career point number 2,000, helping to defeat Parsons College 111-64. His final home game several weeks later marked the last varsity basketball game played in Morgan Gymnasium. Carrodine remains the second all-time leading scorer in school history with 2,128 points. Carrodine's number 20 was later retired in his honor.

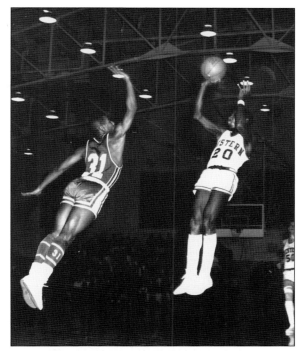

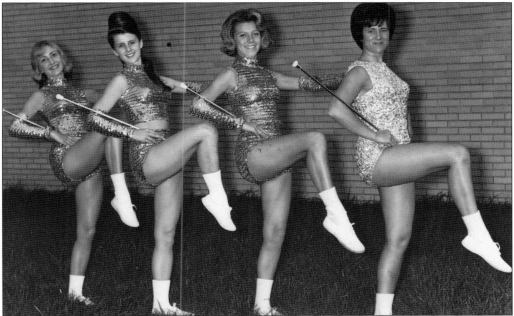

One of the greatest differences between higher education in the United States and other countries is the abundance of extracurricular activities here. One such activity, baton twirling, is full of tradition at WIU. Long part of the WIU marching band show, baton twirling expanded in the 1960s with the addition of the silver girls and the golden girls ensembles. Shown here is a 1960s-era photograph of four WIU silver and golden girl baton twirlers.

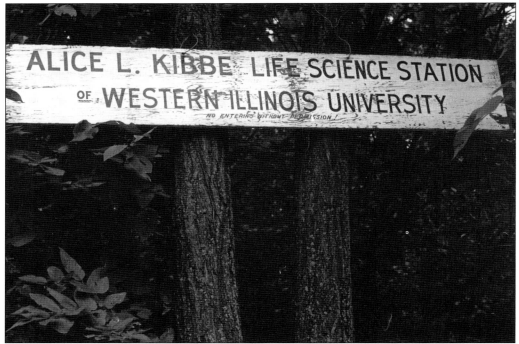

Dr. Alice L. Kibbe donated the original 163-acre tract of lightly touched wilderness overlooking the Mississippi River at the convergence of the Iowa, Missouri, and Illinois state lines in 1964. By 2004, the site had grown to 1,680 acres along with a research building that boasts a modest library anchored by some of Dr. Kibbe's private collection of life science texts. The station's unique mission balances the advancement of scientific research with the necessity to preserve this land for future users.

WESTERN COURIER

The COURIER Reports
News of Western
Without Fear or Favor,
Bias or Prejudice

VOLUME 61 MACOMB, ILLINOIS, WEDNESDAY, NOVEMBER 27, 1963 NUMBER 11

Campus Mourns

REPERCUSSION

"When lilacs last in
the dooryard
bloom'd,"

The times were
different, the
scene the same.

A nation mourning,

A loss so great.

Foolish reasons,
selfish causes,

Destroy faith, hope
and meaning.

A white-winged
dove, a gallant
flag,

Marred by a
hopeless wretch,

A nation mourns,

A soul of strength,
justice, Equality.

The years will hold
ceaseless effort,

By courage
impressed upon
humanity.

A star, a lilac, a
hermit thrush,

Cry out to every
countryman.

A Man, deep love,
a song of death,

Molded together
form greatness,

And Eternity.

 — Carol Lund

November 22, 1963

Friday, November 22, started out as a blustery chilly day. Early in the morning thin, scudding clouds blotted out the sun, cutting out the little warmth it provided. A damp chill seeped in everywhere.

About 12:15 a wind driven rain started. A few of the COURIER staff members were in the office at 12:35 finishing up work on the paper, when the phone rang. Dr. Reef Waldrep, who had just entered the office, answered it. I'll never forget the look on his face as he turned around and said, "The President's been shot."

As I glanced around the room, the several remaining staff members' faces were as white as chalk. Dr. Waldrep was standing at the telephone staring back at us. No one could quite grasp the import of the announcement. The rain was coming down in driven sheets now.

Walking down the hall on the second floor of Sherman, I could easily tell the students who had heard the news. Some walked briskly to their 1:00 classes talking animatedly in groups of twos and threes. Others walked in a daze looking straight ahead. The word spread rapidly, but there didn't seem to be any rush to tell the news. It was as if everyone were in a bad dream. If they repeated the news they would wake up and it would be true.

Under the reel awning covering the exit from Sherman there was a small group discussing and theorizing about what had happened in Dallas, and what was going to happen.

In the main lounge of Seal Hall most of the chairs were taken, but all that could be heard was the rain on the windows, and a radio giving all the bulletins. The men, for the most part, sat staring straight ahead. The TV lounge was just as silent. Only the television could be heard. There was none of the usual undertone of conversations.

About 20 men were crowded into the Graduate Assistant's apartment getting the latest news from his TV.

Everybody, it seemed, had forgotten classes were being held.

The rain continued to pour down, and, about 1:30 rumors began to be reported that the President had died. With each more substantial rumor, there seemed to build a feeling that there was some mistake; that in a few minutes there would be an official report saying he was improving. That report never came. At 1:40 it became official; the President had died.

There was a general air of non-acceptance. There had to be some mistake. The man who had been riding through Dallas beside his smiling wife just couldn't have fallen into her lap with a bullet in his head. The proud father of the two mischievous children couldn't be dead.

All over the campus, people sat looking out at the pouring rain. Sherman Hall was practically deserted. Slowly the groups broke up. Few students could be seen anywhere.

I was in my room at 4:30. I had just begun to realize that "the President" no longer meant Mr. John F. Kennedy. His family, the nation, the world would never look to him for leadership again. Even though we had suffered a tragic loss, the world would continue just as it always had.

I walked to my window just as the sun began to shine through a small break in the clouds. It began to shine through the pouring rain and gloom. In the east a rainbow began to appear. It continued to grow more brilliant until it became a perfect 180° with the entire spectrum visible. To the outside of it another rainbow appeared faintly.

It was hard for those who saw it not to feel a new hope. It reminded some of the quotation from the Old Testament that told of God's promise to Noah after the Flood: ". . When the bow is in the cloud, I will look upon it and remember the everlasting covenant. . ." JACK TUMBLESON

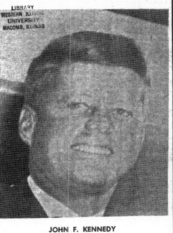

JOHN F. KENNEDY

This picture was made during the 1960 presidential campaign by a COURIER photographer.

Kennedy Tragedy

November 22, 1963 A child orphaned today.
A man died today. A nation grieved today.
A man killed today. A world shook today.
A woman widowed today. Good night.

November 22 was a day revealing in a ghastly, incredible fashion the ignorance of mankind.

On a cold January 20th in Washington a young, sandy-haired man, John Fitzgerald Kennedy, a paragon of vigor and vitality, made a plea to the nation in his inaugural address after taking the oath to the highest office of the United States. He said, "And so, my fellow Americans, ask not what your country can do for you. Ask what you can do for your country."

Two years, ten months, two days later our youngest, most lively president returned to a cold Washington. This time his disheveled hair was not blowing in the breeze. He came encased in a bronze casket. The once vital spark of humanity who had led the nation and the world wisely and conscientiously had been extinguished by the bullet of a sniper. A truly great leader who had touched the lives of nearly the entire population of the United States in a personal manner was dead.

Why did he die? Was it merely the fault of a deranged, revengeful man? We cannot take such a superficial answer. We must look to the underlying cause, to the dissension within our own country, to the hatred and bias which has far too long been minimized. Americans have become too much a people of ideas, often times based on misconceptions, prejudice and fallacies, instead of a people of ideals. The death of Kennedy is a tragic culmination of this malignant hatred, a hatred which he devoted his life towards eliminating.

Obviously Americans did not hear Kennedy's plea during his inaugural address.

Perhaps his death will speak louder.

 CAROLYN SLATER, Editorial Board.

Here is the *Western Courier*, November 27, 1963, coverage of the assassination of Pres. John F. Kennedy.

Lincoln and Washington Halls, completed in 1963, are 14-story residence halls located on the southeast corner of campus. Originally housing over 1,000 men in double rooms, Lincoln and Washington Halls are now coeducational residence halls with single rooms. Lincoln and Washington Halls were part of the solution to provide campus housing to the influx of baby boomer students who arrived on campus in the early 1960s. The towers are joined by a dining hall.

The Blue Key National Honor Fraternity, one of WIU's most exclusive honor societies, came to campus in 1964. Membership was limited to upperclassmen who displayed outstanding leadership ability and above average academic achievement. Additionally, six faculty members were allowed membership at any one time. Faculty members were selected for excellent demonstrated commitment to WIU. In this 1960s-era picture, John Gelling (left) poses with the Blue Key Charter and WIU president John T. Bernhard.

Blenda Olson was a professor of French
and German.

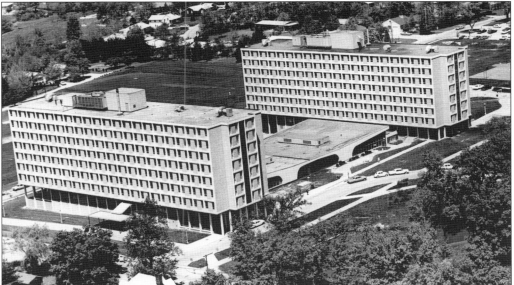

Named after professors and lifelong friends Mabel Corbin and Blenda Olson, the two
eight-story dormitories were initially designated for female students only. Build under
university president Arthur L. Knoblauch to support the enrollment boom of the 1960s,
Corbin Hall was completed in 1962 and comfortably housed 600 residents. Construction
on Olson Hall began in April 1964, and like Corbin it was solely a women's dormitory.
Olson Hall officially closed to residents in the fall of 2006 and currently is used as a
conference center for the university.

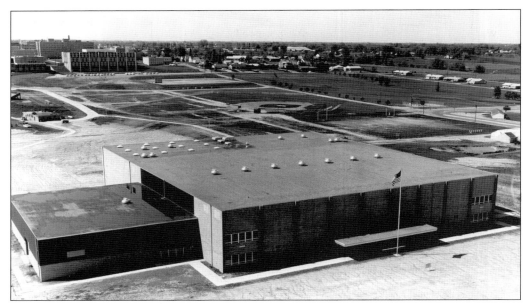

Completed in 1964, Western Hall is home to the men's physical education department and Waste Management Court, named for WIU's corporate partner. Western Hall is the premier arena for basketball and volleyball with student athletes competing in the NCAA Division I Summit League. Western Hall also hosts cultural events for the university and surrounding community. Additionally, it provides classroom and training laboratory spaces for students and offices for WIU employees.

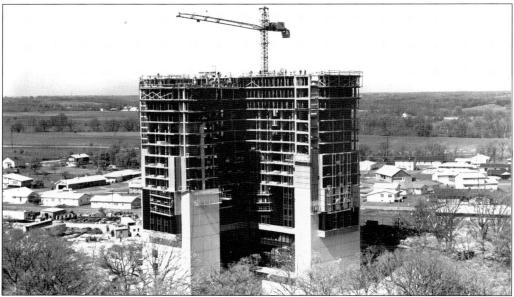

Located on the northwest corner of campus, Higgins Hall opened in 1967 and housed 1,000 female students. The construction of the massive 20-story building upset many people living next door in single-family homes, but the campus needed housing quickly to accommodate the exploding student population. Today Higgins is a coeducational, primarily upper-division residence hall housing approximately 950 students.

The uniforms have changed over the years, but the WIU w has remained the same for the university cheerleaders. As college athletics grew in popularity during the early 1920s, WIU's first cheerleaders, or yell leaders as they were known, took to the sidelines showing their school spirit. In 1926, Eva Purdum became the first female yell leader and held that spot until 1928. The early 1970s brought much-needed equality to men's and women's athletics, and WIU cheerleaders were recognized as much for their physical skill as their ability to cheer on other sports teams.

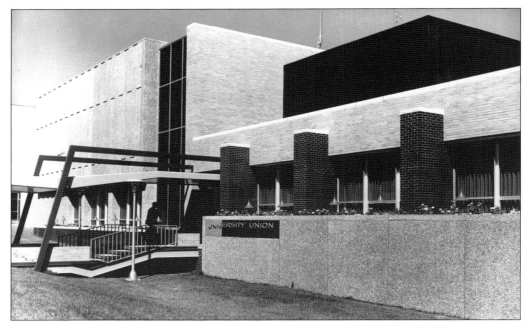

WISTC bought the 40-acre Rigg farm in 1945, and 19 years later, the four-story student union was built. The union has become the center of campus life at WIU with executive conference rooms, elegant ballrooms, a 16-lane bowling alley, a billiard room, and an arcade. The Sandburg Theater is a great place to see a movie. The Union Hotel, on the upper floors, contains 27 guest rooms and 2 suites and provides a spectacular view of Hanson Field. The university bookstore is located within the union, alongside a food court, coffee shop, and convenience store.

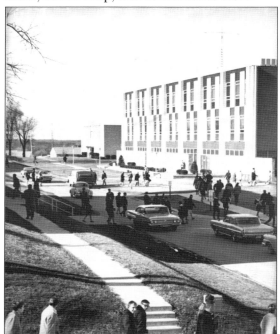

Located on Murray Street, Knoblauch Hall opened in the fall of 1964 as the applied sciences building. The Departments of Agriculture and Industrial Arts were the building's first occupants. The building provided much-needed classroom and laboratory space for these departments. The building's original name was Morrill Hall, after Sen. Justin S. Morrill, famous for sponsoring the Morrill Land-Grant Colleges Act. In November 1972, the building was renamed Knoblauch Hall, in honor of former president Arthur L. Knoblauch.

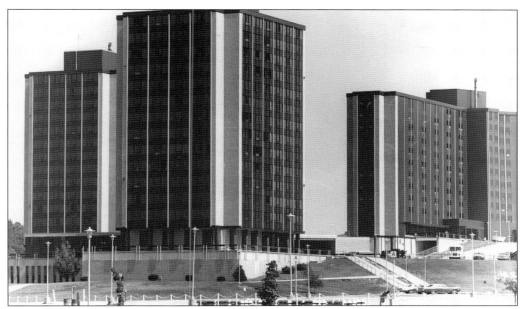

Bayliss and Henninger Halls were constructed in the mid-1960s to help alleviate campus crowding from an exploding student population. Opened in 1966, the 14-story twin towers were built in the northeast corner of campus. Each building housed 507 students, Bayliss Hall for men and Henninger for women. Henninger Hall was named after WISNS's first president, John W. Henninger; Bayliss Hall was named after WISNS's second president, Alfred E. Bayliss.

Many students come to WIU with an academic interest in agriculture. To educate future leaders in agriculture, the university manages its own experimental farm on the northern edge of campus. Students study all aspects of agriculture and agribusiness. In this picture, cattle wander through the barnyard at the laboratory farm, with Henninger Hall towering in the background.

In 1965, WIU acquired a 92-acre tract of land just south of Macomb on China Road from local businessman Frank J. "Pappy" Horn for the university's educational and recreational needs. Consisting of a brick lodge and three cabins and located in a diverse ecological setting, Horn Field Campus has hosted a wide range of events, including freshman camp, wilderness first responder courses, and outdoor skills workshops. Today groups can rent the facility for training and recreational outings. The popular high ropes course is one of its most distinguishing features.

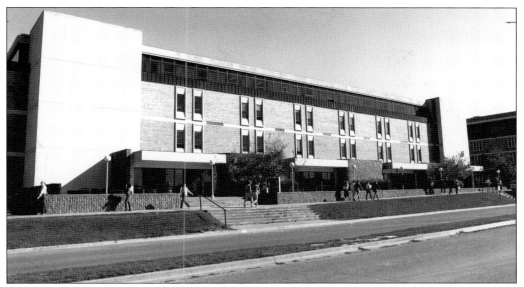

The campus home for the history, mathematics, political science, philosophy and religious studies, foreign languages and literature, and sociology and anthropology departments is named for former president Walter Piety Morgan and was dedicated on May 18, 1968. Costing nearly $2.9 million, Morgan Hall features two 250-seat lecture halls, faculty offices, classrooms, and a computer center.

The 16-story Tanner Hall opened to students in September 1968. Its twin building, Wetzel Hall opened three years later. Tanner Hall's namesake is Gov. John Tanner, the man who authorized WIU back in 1899. Men and women lived in Tanner Hall but were separated by the building's wings. Among Tanner and Wetzel's unique characteristics are the circular dining facilities and student lounges attached to the buildings. Today Tanner is a coed building, serving sophomores, juniors, seniors, and graduate students.

Dr. John T. Bernhard arrived in Macomb in 1968. WIU's sixth president was previously employed at Brigham Young University in Utah. He took WIU's reigns during a tumultuous time of student unrest and faculty displeasure. Bernhard worked hard to soothe these campus wounds, and he was generally successful. Bernhard gave more authority to student government, and his administration treated students as adults rather than as children. Bernhard remained president until 1974, when he left for the presidency of Western Michigan University.

St. Paul's parish began on-campus ministry at WIU in the early 1950s. As the Catholic community of students and faculty grew over the years, the Newman Center was established as an independent worship facility. Located on University Drive just west of Horrabin Hall, the Newman Center was dedicated on December 10, 1978. The building houses a full-time chaplain and support staff. A unique feature of the center is the chapel, open 24 hours a day for use by students, faculty, and the surrounding community.

Located just south of campus on North Clay Street, the Lutheran Student Center is a ministry of Immanuel Lutheran Church-Missouri Synod (LCMS) in Macomb. Under the direction of the Central Illinois District of the LCMS, the Lutheran Student Center was built in 1968 as an outgrowth of the Delta Gamma campus ministry at WIU. The facility is still owned by the Central Illinois District, with the strong support of the local Macomb congregation.

Here is Katharine Thompson, upper-grade principal at the training school.

Following the coeducational living trend developed on campuses across America, Thompson Hall housed male and female students in separate wings on 19 floors. Constructed on the site of the old university golf course and opened in 1969, the residence hall is named after Katharine Thompson, who in 1922 was made upper-grade principal at the training school. Thompson Hall has residential living space for 950 first-year students and the honors college. The coed student lounge was the first of its kind— open 24 hours a day.

One of the key aspects of WIU's agricultural experimental farm is its research component. WIU faculty in agriculture are active researchers, trying to make life more productive and prosperous for farmers. In addition to beef and swine, WIU's agriculture research has included rams, sheep, and lambs. Here the sheep teaching research center is shown on the north edge of campus, with Higgins and Thompson Halls rising in the distance.

Whenever new facilities are built, one of the first construction activities is the ceremonial groundbreaking. Here university president John Bernhard (with shovel) is flanked by other WIU administrators, including Franklin Gardner, Richard Poll, Darwin Tinker, Loren Robinson, and Victor Sheldon at the groundbreaking ceremony for the Agricultural Experiment Station in May 1970.

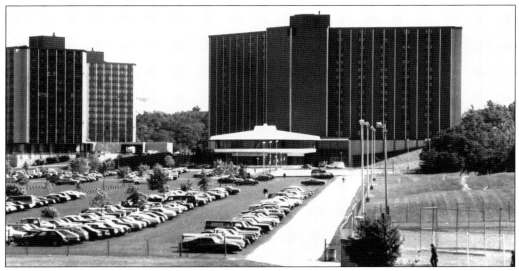

Located on University Drive on the north edge of campus, Wetzel Hall houses nearly 700 first-year students. Each floor in the 13-story building is divided into a male and female wing. On April 3, 1971, the hall was dedicated for WIU's former head of the manual training department, Wayne Wetzel. The most recognizable feature of Wetzel Hall is the circular dining room and student lounge.

WIU's College of Business got a new home during the 1970–1971 school year when Stipes Hall opened along Western Avenue. Named for former chair of the teachers college board and board of governors Royal Stipes, the building features over 20 classrooms, seminar rooms, computer laboratories, and other essential meeting space. Stipes's crowning feature is its fifth floor, with glass walls and a panoramic view of the WIU campus and the Lamoine River valley. WIU's College of Business and Technology still occupies the building today, along with the renowned Illinois Institute for Rural Affairs.

With a campus population of over 11,000 students, many of whom live in close quarters, it is imperative for the university to have an efficient health center to treat the students' diverse medical needs. In early 1973, the current health center, located on the corner of Murray Street and Western Avenue, was dedicated and named after former president Frank A. Beu. Beu Hall is staffed by an excellent team of physicians, nurses, pharmacists, health educators, and others dedicated to keeping the WIU community healthy.

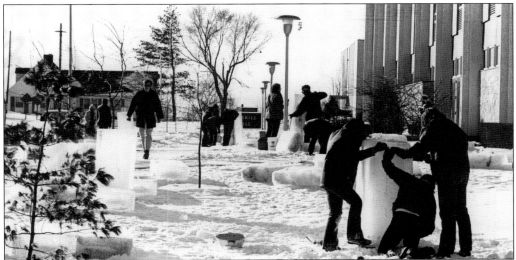

College cannot only be about studying hard. There are also times when students need to let loose, and what better way is there to celebrate a new snowfall than to go outside and enjoy it? In this image, a number of WIU students are playing in the snow outside Merrill Hall, which was later renamed Knoblauch Hall. The student health center (Beu Hall) is situated just beyond Merrill Hall.

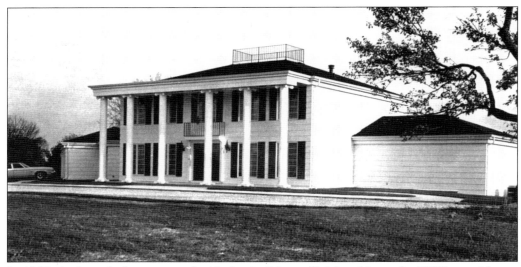

In 1968, the board of governors decided to build an official residence for WIU's presidents. In 1973, university president John Bernhard and his wife moved into the nine-room Colonial-style home on a hill overlooking the entire WIU campus north of the LaMoine River. The house cost $150,000 to build and an additional $35,000 to furnish. A special feature to the home was a mural painted in the dining room by Dr. Donald Scharfenberg. WIU's presidents still live in the home, which also hosts a number of public events each year.

The large green space between Tillman, Memorial, and Sherman Halls is a favorite campus hangout for students between classes. The wide sidewalks are frequently traversed by WIU employees looking for a little exercise during work breaks. This image, from the 1970s, shows Tillman Hall, the rear of Simpkins Hall (now the College of Fine Arts and Communication Recital Hall), and the rear of Sherman Hall. Memorial Library is located just out of the picture to the left.

Here is professor of biology
Dr. Harry Waggoner.

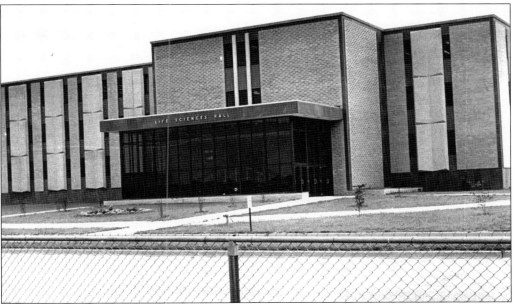

Located on the corner of Western Avenue and University Drive, Waggoner Hall opened in 1968 as the life sciences building. It was renamed in 1970 in honor of biology professor Harry Waggoner. Waggoner Hall provided important laboratory, classroom, and office space to students in the biological and life sciences. Today the Departments of Biological Sciences and Psychology reside in the building.

73

Here is professor of chemistry Dr. Frederick Currens.

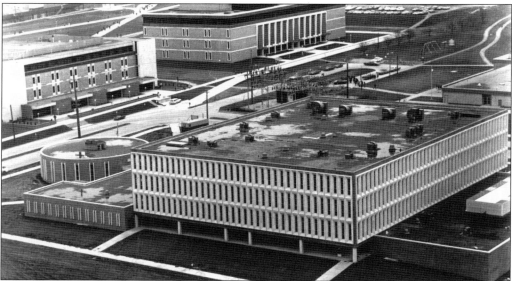

The university's need for a modern facility to house the chemistry and physics departments was addressed with the completion of Currens Hall in the fall of 1970. The building's 142,172 square feet is comprised of laboratories, lecture halls, faculty offices, and a unique circular research library and reading room. Named for the former chemistry department head Dr. Frederick Currens, the building also houses WIU's very first biochemistry laboratory.

As college campus populations grew in the 1960s, the number of black students at WIU increased too. By 1969, WIU joined the national trend of providing a place for ongoing academic and social experience for African American students. The Black Student Association was entrusted with finding a permanent name for the Black Cultural Center. In 1970, the building was renamed in honor of the famous Illinois African American poet Gwendolyn Brooks for her "commitment, encouragement, humanitarian service and her personal inspiration to African American students at Western Illinois University." Brooks visited the campus and center many times until her death in 2000. The Gwendolyn Brooks Center remained located in Burns Hall on West Adams Street until 2002. At that time, it moved into the larger University Services Building on University Drive. The center will relocate again into the brand-new multicultural center on Murray Street when it opens in spring 2009.

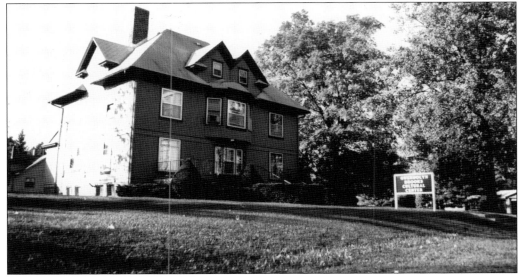

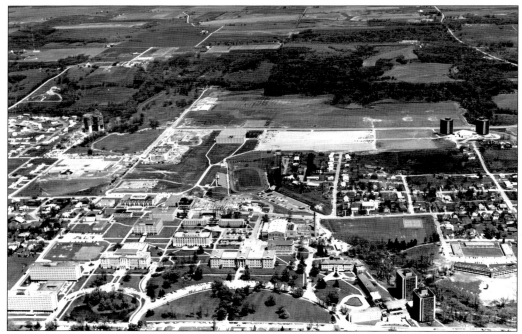

These two images, from 1966 above and 1971 below, give an excellent visual representation of just how much the WIU campus grew during this short five-year period. New residence halls in the northeast and northwest corners of campus are clearly visible. Additional construction, including Stipes and Waggoner Halls, also appears along Western Avenue in the later picture. The 1960s and 1970s were a transformational period of construction on campus.

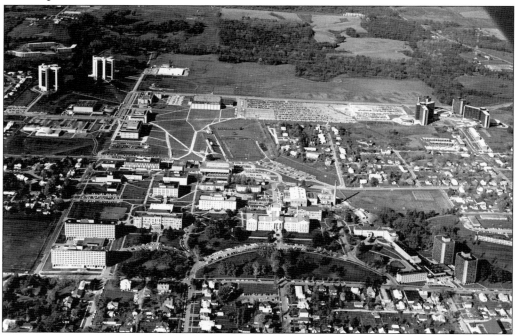

Five

MALPASS AND WAGONER
1974–1993

Leslie F. Malpass assumed the WIU presidency in mid-1974. The school's period of whirlwind growth and development during the 1950s and 1960s was over. Campus construction projects decreased considerably. WIU began to resemble the university it is today in regard to total enrollment, size of the faculty, and the campus's physical appearance.

Stagnant and decreasing state budgets were a constant problem for Malpass. Combined with decreasing enrollments, WIU's financial situation was not rosy. Consequently, salaries were lower than at peer institutions, and programs were cut. To supplement lower state appropriations, Malpass emphasized external fund-raising, and he attracted Ralph H. Wagoner to Macomb to lead the university's fund-raising initiatives and increase WIU's profile throughout the region.

One of the greatest accomplishments of the Malpass administration was the construction of the current library, now named in his honor. The stunning building, designed by Japanese architect Gyo Obata and WIU's director of facilities planning Donald Rezab, was desperately needed. Upon its dedication in 1978, the library instantly became one of WIU's most important, user-friendly, and architecturally significant facilities.

After a successful 13 years as president, Malpass stepped down. Breaking with WIU tradition, his successor was not hired externally. Ralph H. Wagoner, WIU's vice president for public affairs and development became president. Wagoner was an easy-going, popular administrator, and his great fund-raising successes compensated for his lack of academic affairs experience.

Budgetary limitations continued to plague WIU during Wagoner's term. He was forced to make several programmatic and athletics cuts while raising student tuition to balance the books. Fund-raising continued under Wagoner, but it was not enough to compensate for the reductions from Springfield. Wagoner remained popular on campus because of his charming personality, but after just six years at WIU's helm, he left for the presidency at a small private college in South Dakota.

Not all of Wagoner's term involved cuts. He understood WIU's significance in the region, and he worked hard at increasing the school's official presence in the Quad City area. WIU had long been active in the Quad Cities, but the opening of the Rock Island Regional Undergraduate Center made this link more visible and permanent.

The Malpass and Wagoner administrations worked hard at improving the academic and extracurricular experience for WIU students and employees and residents of the region. Their efforts were generally successful. Their focus on the Quad City area was particularly significant, as future presidents looked to grow WIU's presence in that important market.

WIU's seventh president, Dr. Leslie F. Malpass, assumed the office in 1974 after holding various academic positions in Illinois, Florida, and Virginia. Malpass focused heavily on strengthening the university's academic reputation and solidifying its financial base. Malpass guided the university from the quarter to semester system and oversaw the organization of the faculty labor union. Here Malpass is pictured with Congressman Lane Evans (Democrat, Illinois), whose political papers are now housed in the WIU archives.

A golf course on the WIU campus can be traced all the way back to the school's normal school days, when a small three-hole course was located on the Sherman Hall lawn. In the 1940s, a nine-hole course was built in the northwest part of campus. In 1970, the nine-hole golf course was moved again, to former agricultural land just north of the Lamoine River. A million-dollar gift, given by former WIU golfer Eric Gleacher in honor of legendary WIU golf coach Harry Mussatto, made it possible to expand the course to its current 18 holes. Today the Harry Mussatto Golf Course is the primary public facility for the city of Macomb and one of the finest courses in western Illinois.

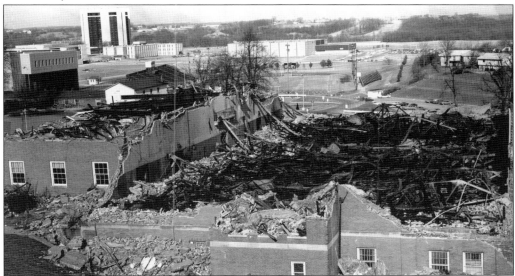

A carelessly laid acetylene torch on Thanksgiving Eve 1970 caused a devastating fire that engulfed the building once known as Morgan Gymnasium. Two years prior, the structure was renamed Brophy Hall, after Dr. Kathleen Brophy. Professor and head of the women's physical education department for nearly 31 years, Brophy first came to WIU in 1936. Despite the fire, not a single scheduled class was cancelled, as other campus buildings were used to complete the semester.

The Gwendolyn Brooks Black Gospel Choir was organized at WIU in the early 1970s as part of the burgeoning black movement on campus. Affiliated with the Brooks Cultural Center, the popular coeducational choir was later renamed the Heritage Ensemble. Members performed gospel songs and traditional African music at concerts on campus and throughout Illinois.

First organized as the Sherman Club in early 1908, WIU's debate team grew, and by the 1970s, it earned a much-deserved national reputation for excellence. Fred Johnson (standing third from left) was one of the debaters who represented WIU at the prestigious Ford Motor Company's national tournament in early 1971. During the 1971 debate season, WIU was the only school in the Illinois public college system to compete at the national debate tournament.

Here is professor of physical education Dr. Kathleen Brophy.

The women's physical education department moved into the new Brophy Hall in the fall of 1973. At nearly 130,000 square feet, the building houses an Olympic-sized swimming pool, several athletic courts, classrooms, and office spaces. Extensive renovations in 2005, including updated weight rooms and a new biomechanics laboratory, help ensure that Brophy Hall will continue to meet the needs of WIU's student athletes and coaches for years to come.

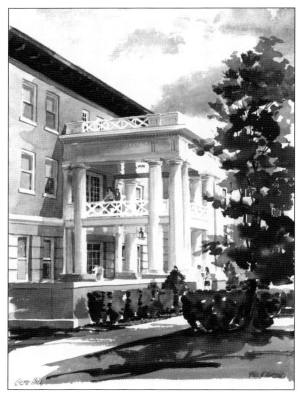

Illinois artist Paul N. Norton was born in 1909 in Moline. During his lifetime, Norton completed more than 500 watercolor paintings. He also found his niche completing commissioned work for governmental agencies, including the United States Capitol and Lincoln Memorial in Washington, D.C. In 1974, Paul N. Norton was commissioned by WIU to complete several watercolor paintings, in celebration of the university's 75th anniversary. His WIU watercolors are on permanent display in the archives and special collection reading room in Malpass Library.

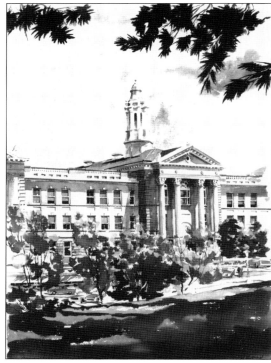

Meandering through the northern and western edge of the WIU campus, the Lamoine River is a favorite place of solitude for the WIU community. A relatively short river of only 100 miles, the Lamoine is a Mississippi tributary, and it flows into the Illinois River near Beardstown. While most of the WIU campus lies south of the Lamoine, a small part of it is on the north side of the river. Most students traveling back and forth use this old wooden footbridge, located between the Lamoine Village and the land just north of Thompson Hall.

In the late 1960s, WIU was suffering from a shortage of housing as the campus population increased rapidly. The need was especially acute for married students, many of whom brought their families to Macomb. In the fall of 1970, this problem was addressed with the opening of Lamoine Village, a 232-unit apartment complex designed for married students. Located on the opposite side of the Lamoine River in the northern part of campus, Lamoine Village provided lots of open space for families to assemble and for children to play.

Mowbary Hall, located on Murray Street, just south of the university union, is often referred to as the public safety building. Mowbary Hall was dedicated in 1974. It was named after John C. Mowbary, a WIU graduate and justice of the Nevada Supreme Court. Today the building is home to WIU's police department, parking services, and the dispatchers for the school's emergency medical team.

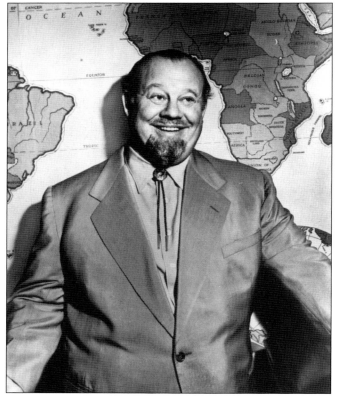

One of WIU's greatest celebrity friends was folk singer and actor Burl Ives. Ives grew up in eastern Illinois, but he had a brother living just west of Macomb in Colchester. During the 1970s and 1980s, Ives held numerous fund-raisers on behalf of WIU when he was in the area. One of his favorite causes was a performing arts center, a facility that still has not been built. Later Ives donated many of his personal papers, recordings, scrapbooks, and other materials to the WIU Archives and Special Collections Library.

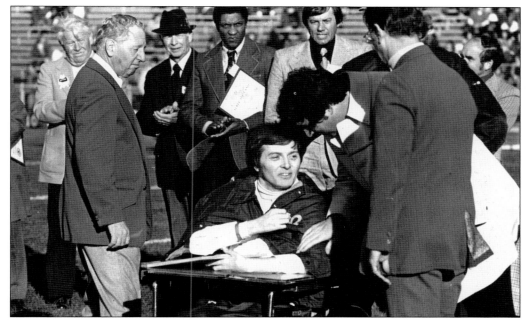

A special ceremony took place during halftime of the 1975 homecoming football game. At that time, Vince Grady was inducted as an honorary member of the WIU Athletic Hall of Fame. Grady had long been an inspiration to students and staff of WIU, and his hall of fame induction solidified it. Grady was presented a plaque commemorating the event wearing an Alpha Phi Omega jacket. The fraternity brought Grady to and from many WIU functions, visited him in the hospital, and made him a brother in their fraternity.

WIU freshman Vince Grady was critically injured during the final junior varsity football game of the 1958 season against Northeastern Missouri State University. Grady, the youngest of 16 children in an impoverished family, paid this tuition by working for two years before attending WIU. He became an inspiration to all for his positive outlook on life. He was initially paralyzed from the neck down after the accident and would eventually gain some use of his left arm. In 1968, the large green practice field near North Quad was named in his honor.

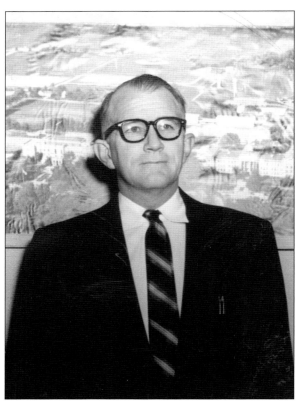

Here is vice president for business affairs James M. Grigsby.

The James M. Grigsby Physical Plant building, located on the northern edge of campus, is the primary facility for the men and women who make sure the mechanicals and other day-to-day operations of WIU's buildings function smoothly. It is also the home for WIU's fleet of vehicles, including several environmentally friendly hybrid cars. The building is named after Grigsby, WIU's business manager and vice president for business affairs from 1949 to 1975.

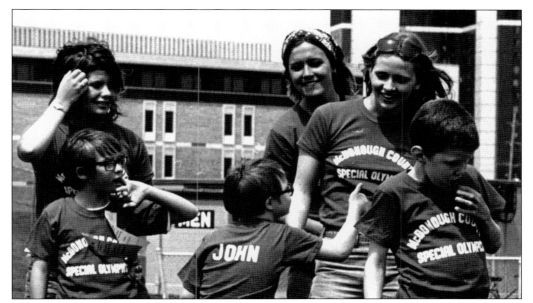

WIU faculty, staff, administrators, and students are actively engaged in the Macomb and McDonough County community. Many community organizations rely heavily on campus volunteers to operate their programs and services that help make Macomb and McDonough County a great place to live and work. One such organization, the Special Olympics, used WIU facilities and student volunteers to offer its athletic competitions to local disabled children.

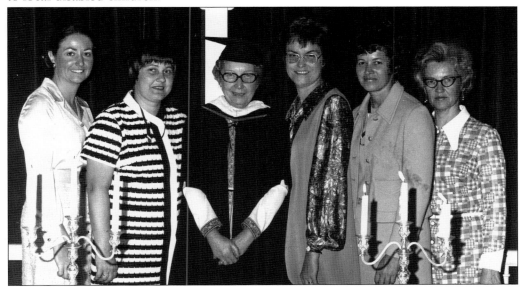

As an institution of higher education, WIU encourages the scholastic endeavors of its students and faculty. One such organization, Alpha Lambda Delta, is a national freshmen women's honorary society. The national Alpha Lambda Delta remained a single-gender organization until Title IX made it coeducational. In this picture, from left to right, Linda Young, Nell Koester, Ann Meierhofer, Beatrice Wehrly, Rosemary Aten, and Emily Leonard pose at an installation ceremony.

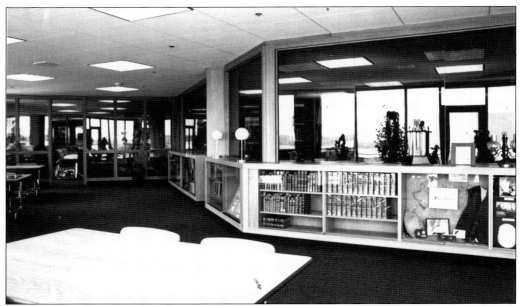

The WIU Archives and Special Collections Library preserves the history and culture of WIU and a 16-county region in west-central Illinois. Located on the sixth floor of Malpass Library, the archives has a stellar reputation for service to the region. Noteworthy collections include the Baxter-Snyder Center for Icarian Studies, the Center for Regional Authors, the Decker Press Collection, and the regional Illinois State Archives materials. Long-serving archives employees include Gordana Rezab, John E. Hallwas, and Marla Vizdal.

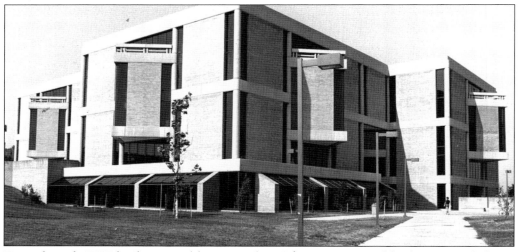

Even though WIU built a new library in the 1960s, it was quickly determined that a larger facility was required for the growing school. In 1975, funding was secured in Springfield, and the complicated work of constructing one of WIU's most architecturally unique buildings began. Director of facilities planning Donald Rezab, working with chief designer Gyo Obata of Japan, came up with the unique pinwheel design for the library. The building's cornerstone was put in place in 1977, and the building was finished by the summer of 1978.

The new university library was a vast improvement over previous libraries, with modern technologies and plenty of space for student collaboration. The $12.5 million facility had shelf space for over a million books, a stunning atrium with countless plants, a massive skylight with a large hanging sculpture, a glass garden lounge, and a bright glass area formerly housing the International Tea Room, now the Illinois Centennial Honors College. In recent years, the university library has undergone numerous changes to keep it relevant to today's college student. The changes include additional computers and other information technologies, a coffee bar, and expanded operational hours. For the first 20-plus years of its operation, the building was simply known as the "university library." In 2001, the building was renamed in honor of long-serving president Leslie F. Malpass. Other campus units housed in the building include the Center for Innovation in Teaching and Research and some of the academic computing offices.

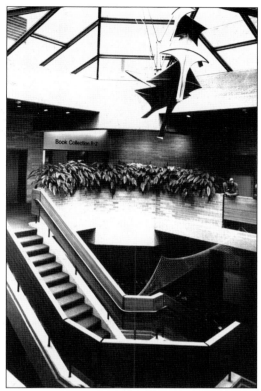

Beloved actor and comedian Bob Hope made two visits to the WIU campus. In 1975, he visited campus and was the headlining performer for the annual Parents Day celebration. Just five years later, in 1980, Hope returned to Macomb and participated in the Homecoming festivities. Hope was a fantastic campus visitor. He posed for pictures with campus landmarks including the Rocky mascot statue and donned Western clothing.

Located on the second floor of the Malpass Library, the International Tea Room was a wonderful place for faculty and others to meet and discuss issues over coffee, tea, and various desserts. The tearoom continued a campus tradition that was started on the other side of campus, in Grote Hall. The bright, sunny room was a popular place to assemble and interact informally. The space is now occupied by the Illinois Centennial Honors College.

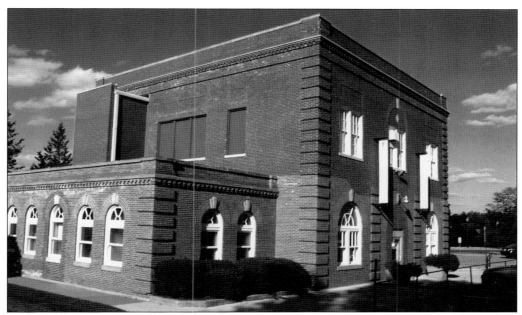

Located in the original power plant building behind Sherman Hall, the WIU art gallery offers the campus community opportunities to study and enjoy an impressive variety of visual artwork. Permanent collections include several examples of WPA murals dating from the Great Depression and etchings from Old World masters like Rembrandt and Albrecht Durer. The art gallery's mission is to collect, preserve, exhibit, and interpret these stunning works for all.

A highlight of any year's homecoming festivities is the selection of the court and the coronation of the king and queen. A selection to the homecoming court is a great honor, as the entire group participates in the parade, a halftime celebration during the football game, and other events throughout homecoming week. In this 1983 picture, homecoming king Dennis Alexander and queen Tanesha Gray take a moment to pose for the camera.

Dr. Ralph H. Wagoner served as WIU's eighth president. He arrived first on campus in 1977 as the vice president for public affairs and development. A decade later, in 1987, Wagoner assumed the presidential office vacated by Leslie F. Malpass. Wagoner's six years as WIU's president were characterized by constant budgetary and growth problems, but his likeable personality made the difficult times easier to overcome.

Activism has long been a focus for students at WIU. Students are involved in charities, politics, and other community organizations seeking to improve society. As seen in this picture, Bayliss Hall residents collected empty soda bottles and donated the deposit funds to local charities. An estimated $230 was raised in this event. Pictured are Larry Owen of Rushville, Kevin Roeske of Rollings Meadows, and Dale Doty of Pecatonica.

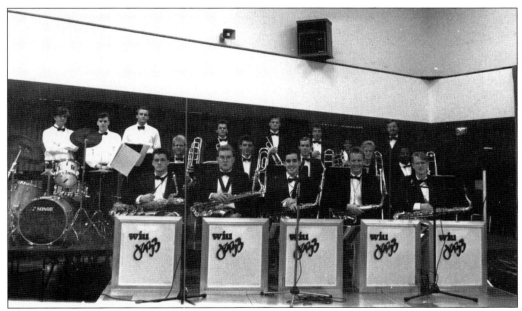

Jazz ensembles and bands have existed at WIU for over a half century, debuting in 1957. They perform at locations throughout the state and region, to the delight of their enthusiastic followers. WIU jazz music has even been heard by audiences in Europe. In this 1990 photograph, the Jazz Studio Orchestra poses before a performance.

The 700 acres of university agricultural fields provide a comprehensive learning environment for agriculture majors and researchers throughout western Illinois. From the cultivation of corn and soybeans to research into alternative crops like milkweed or cuphea to livestock management education, WIU's agriculture field laboratories provide academic experience to students and practical solutions for regional commercial farmers. Organic farming research and teaching is a departmental specialty, and since 1989, new techniques developed at WIU have improved crop quality and quantity.

In past years, WIU's Department of Agriculture sponsored a boar sale. Buyers and sellers came together to look at the boars and make a deal. Most years this event went without notice, but the 1973 sale made headlines when $11,000—a world record—was paid for this boar. From left to right, Ed Simpson and Stan Martins purchased the animal. Steve Goldenstein and Walter Northcutt raised the boar, and they gladly took home the large check the boar brought.

Fraternities and sororities complement the WIU ideal of exemplary citizenship by organizing social, charitable, and public works projects throughout the WIU community. The two oldest Greek letter societies at WIU were established in 1910. After fraternity members assaulted a student in 1912, school president Walter Piety Morgan, in an attempt to control and dictate campus life, disbanded Greek organizations. When Frank A. Beu took office in 1942, he reinstated fraternities and sororities and encouraged their campus presence. Competition between Greek fraternities is common and fosters teamwork and brotherhood. Today Greek life is represented by 18 fraternities and 10 sororities governed by the interfraternity council. The council has made great advancements in dealing with the two biggest negative issues associated with campus Greek life, alcohol abuse and the practice of hazing.

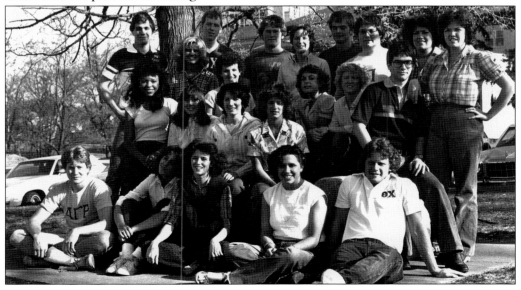

Schools are often defined by their mascots. WIU is no exception. In 1958, the first Rocky was an English bulldog purchased by the student government, and he claimed Hanson Field as his turf. He was named Colonel Rock in honor of famed football coach and retired marine Col. Ray "Rock" Hanson. Today Rocky stands on two legs as he cheers all 20 WIU varsity teams to victory. WIU remains the only public school allowed to use the official marine corps seal, mascot, and the nickname Fighting Leathernecks. This is one more reason Rocky is in a class by himself.

More than just the university's mascot and the furry face of WIU athletics, Rocky is an ambassador to the entire WIU community, promoting a fun and healthy lifestyle. He hosts an annual five-kilometer Rocky Run around campus. For younger fans, 12 and under, Rocky's Club provides the chance to hang with this lovable bulldog during home games, eating tasty snacks and winning fabulous prizes. Rocky has left his mark around WIU's campus with his yellow paw prints and a 900-pound statue at the north gate of Hanson field that receives frequent paint jobs during homecoming.

The Western Courier

Western Illinois University · Wednesday, January 16, 1991 · Vol. 92, No. 45 · 24 Pages

Shawn Harvey Photo

...aroline Little, Lisa Bergwell and Kim Sarich keep the flame burning during the candlelight vigil held in protest ...f the Gulf crisis. Young and old offered support to the local peace movement last night in Chandler Park.

Eleventh-hour sees candlelight peace vigil in Chandler Park

by JOHN REYNOLDS
Assistant News Editor

Between 50 or 60 people braved snow and freezing temperatures to take part in a candle-light vigil in Chandler Park last night to show their support for a peaceful settlement to the gulf-crisis.

According to Kelvin Malone, a WIU student and one of the organizers of the vigil, it was held because something needed to be done.

"This is very serious business," said Malone, "we thought that a peaceful and quiet demonstration would get our message across."

People who attended the vigil included WIU students, WIU faculty, and Macomb residents. The group met at the pavilion in Chandler Park, and quietly marched around the square.

Although the participants were divided on their individual feelings about the role of the United States in the Gulf, all who attended wanted a peaceful settlement.

Chuck Caudill, who is in the reserves, supports the American troop deployment, and he doesn't think Saddam Hussein should be allowed to profit from his invasion of Kuwait. However, he would like to see a peaceful solution to the crisis.

WIU student Krissi Berolla has a brother serving in the military, and she doesn't believe that all of

See Vigil Page 8

While Bush weighs options, Americans protest against war

By UNITED PRESS INTERNATIONAL

From the White House gates to the incense-filled streets of San Francisco, the churches of Texas and Ohio and the town halls of Maryland and Massachusetts, Americans urged President Bush Tuesday to give peace more of a chance and stay the hand of war in the Persian Gulf.

With less than 12 hours to go before the U.N. deadline demanding Iraqi invaders end their nearly six-month occupation of neighboring Kuwait, thousands of demonstrators continued an intense round of vigils, rallies, prayer services and sometimes angry flag-burning demonstrations calling for peace.

Many noted the war deadline falls on the birthday of Martin Luther King Jr., the martyred apostle of non-violence. Others warned about repeating Vietnam.

"We find it extremely insensitive to the African-American community that Martin Luther King's birthday is being used as a deadline for war," said Kathy Flewellen, a spokeswoman for the National African-American Network Against the War.

Tuesday's demonstrations, which continued a host of prayer vigils Monday night, began before dawn when several thousand demonstrators, many waving sticks of burning incense and re-creating the sights and sounds of the '60s, took to the streets of San Francisco, shutting down the financial district.

The marchers were led by black-clad drummers on stilts who could be heard blocks away through closed windows. A contingent of 50 people, carrying a banner declaring themselves "Vietnam Vets Against the War," chanted anti-war slogans as they passed the federal building and got a large ovation from the crowd as they passed.

About 70 people lay down in body bags in front of the building but police reported no confrontations or arrests at mid-morning.

But police arrested five demonstrators for kneeling and praying in front of the White House at a pre-noon rally that drew some 300 people and was expected to continue growing as the day progressed.

Among the protesters were 30 Peace Corpse volunteers, chanting "give peace a chance" in Arabic. They said they had been evacuated from Morocco, Tunisia, Pakistan and Mauritania by the State Department.

"I protest the whole evacuation," said Jennifer Trapp, 24. "I protest that I don't agree we have to go to war. We have no business being there."

It's half past twelve...wartime?

WIU faculty give their viewpoints on Gulf Crisis situation

by AMY SCHABACKER
News Editor

As the final hours of peace negotiations slip away, opinions on potential war between Iraq and

Opinions

The Editorial Board overviews the Persian Gulf situation and sides with the President.
Page 4

Features

Cathy Young goes sailing with Physical Plant's own James Millmeyer.
Page 12

Sports

Cleveland State gives the 'Necks their 11th consecutive loss.
Page 24

the rest of the world vary drastically. Many factors tend to play roles in the formation of points-of-view by experts and amateur politicians alike.

"The crisis is hard to put in a few words. It's obvious that things are in a pretty grave state," said Darrell Dykstra, associate professor of history at WIU. "At this point we are about 13 hours from the deadline and it doesn't look as if any diplomatic solution will be

reached. Once you pass the deadline things are up in the air, we are definitely in a hostile situation. Things don't feel very good."

According to Richard Hirtzel, associate professor of political science at WIU the United States' participation in the Gulf Crisis is not worth any benefits that may occur as a result of military involvement.

"I think essentially Kuwait is not worth the price we would pay,"

said Hirtzel. "We are acting like Pearl Harbor just got bombed. We have Hussein contained. He is not going to go anywhere, we should just continue to contain him."

Hirtzel attributes the rising crisis as simple politics.

"Boundaries are not static. There are 160 nations in the world and we cannot insure all of those borders and boundaries," said Hirtzel. "We ignore others, so why are we so worked up about this? The

desert is not worth it and the oil is not worth the lives that will be sacrificed."

Dykstra agrees on the serious consequences that could arise from a war in the Persian Gulf.

"The situation is potentially devastating. If you look at the accumulated oil products there is the potential for a lot of destruction," he said. "It could spread beyond Kuwait and Iraq. We could see
See OPIN Page 8

BOG saves deaerator tank with $33,949 OK

By JIM KOUKAS
Staff Writer

Authorization for repairs to a deaerator tank in the Western Illinois University Heating Plant was given by the Board of Governors of State Colleges and Universities on Thursday, December 6, 1990.

Receiving a contract for $33,949 was Olds Boiler and Welding from Moline.

"The repairs to the deaerator tank will not effect the tuition at all," Director of Planning for the Physical Plant George Goehner said.

The deaerator tanks take in condensation, remove impurities, and

then send the "return water" to the boilers.

"The repairs to the deaerator tank should be finished by the new year or a little after," Goehner said.

There are three deaerator tanks. The deaerator tank that is being repaired is over twenty years old. Repairs to the deaerator tank

began on January 2, 1991.

These repairs, which were necessary because of the corrosive nature of the condensate water, consist of the replacing of the walls of the tank. While one deaerator tank is under repair the other two deaerator tanks must be running to provide enough steam to warm the campus.

Here is the *Western Courier*, January 16, 1991, coverage of the beginning of Operation Desert Storm in Kuwait.

Six

SPENCER AND GOLDFARB
1994–2008

After a nationwide search, Donald Spencer became WIU's president in 1993. He arrived at WIU at a time when academic reorganization was necessary, and his experience in this arena made him a wise choice. Under Spencer's leadership, WIU reduced its number of academic colleges from six to the present four, and other administrative restructuring occurred.

Spencer emphasized providing the premier undergraduate experience among Illinois public universities. He accomplished this by implementing a new student convocation ceremony, starting Founders' Day, an annual celebration of WIU and its host communities, and providing additional services to aid students in their academic and personal success at WIU. With overwhelming student support, the new campus recreation center opened in 1997. In 2004, the recreation center was named in Spencer's honor.

Another Spencer innovation was the conversion of WIU's residence halls to offer single rooms as the predominant housing option. Furthermore, his administration implemented GradTrac, a promise that WIU will provide all courses necessary for students to graduate in four years or WIU will absorb additional tuition costs. WIU's unique cost guarantee, developed in 1999, locked in tuition, fees, and room and board for four years for incoming freshmen. This proved so popular with students, parents, and legislators that it became standard practice at all Illinois public universities in 2004.

President Spencer retired from WIU in late 2001, and the search for WIU's 10th president began. In July 2002, Alvin Goldfarb took office. Through 2008, Goldfarb's administration has focused on securing funding for the WIU-Quad Cities riverfront campus and for a performing arts center for the Macomb campus. President Goldfarb's background as a theater professor and interest in the performing arts makes him an effective voice on behalf of the proposed facility.

WIU's first doctoral program, in educational leadership, began in 2006, with the first students graduating in 2008. Other curricular additions during Goldfarb's administration include nursing, museum studies, and religious studies programs. WIU's cost guarantee, previously reserved for undergraduate students, was expanded to include graduate students too.

Now in its second century, WIU is an institution proud of its normal school origins, but one that has grown into a comprehensive university and is looking ahead to its next 100 years of service to the people of Illinois and beyond.

Provost Burton Witthuhn served as acting president in 1993, until Dr. Donald Spencer was named WIU's ninth president in October of that year. Dr. Spencer was most recently provost at State University of New York-Geneseo, and he brought to WIU the knowledge necessary to battle decreasing enrollment and a commitment to the undergraduate experience. President Spencer was also keenly interested in expanding WIU's presence in the Quad Cities. President Spencer remained at WIU until retiring in December 2001.

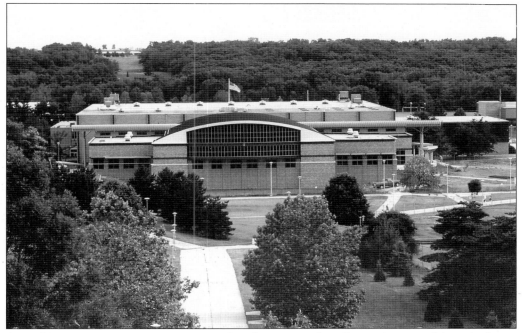

A quality campus recreation center has become a key factor in recruiting students today, and WIU's Spencer Student Recreation Center is an exemplary recruiting tool. The trilevel building contains state-of-the-art fitness equipment and facilities, including a 25-yard pool, a large weight room, and classrooms for group workouts. The Oasis, a place to enjoy a snack, cool down after a workout, or hangout with friends, is a popular meeting place for students. The recreation center opened in 1997, and it was renamed in honor of university president Donald Spencer in 2004. The Spencer Student Recreation Center underwent a multimillion-dollar expansion in 2008, expanding the facility by nearly 21,000 square feet.

In May 1998, WIU students voted overwhelmingly in favor of implementing a student fee to operate a campus bus system. Named Go West, the bus service was an immediate success with over 640,000 rides given during the first year of operation. Go West was soon integrated into the existing McDonough County public transportation network, and students were able to travel all over the city for free. By 2006, riders made over 1.35 million trips on Go West buses each year, making it one of the largest public transportation systems in the entire state of Illinois.

Founded in 1983 as the honors program, the Illinois Centennial Honors College exists to provide "an enriched academic curriculum with opportunities for research, performance, service-learning, and professional growth within the context of a diverse community committed to excellence." On average, 500 highly qualified students are enrolled in the honors college at a time, and over 100 scholarships are awarded to honors students. The honors college is located on the second floor of Malpass Library, and it received its current name in 1999.

Jazz musician Al Sears was born in Macomb on February 21, 1910. He lived here until the age of 8. Known for his improvisational skills, this self-taught tenor saxophone player jammed with the best jazz musicians in history. Sears's 1951 hit "Castle Rock" and the 1960s album *Swing is the Thing* solidified his place as a great jazz musician.

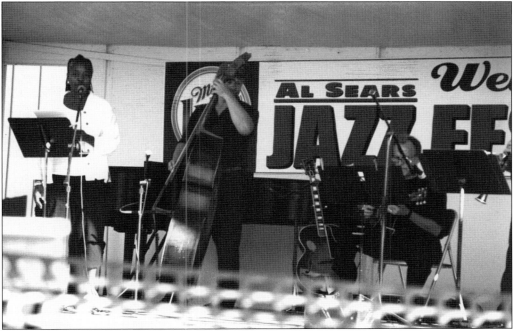

First held in 2002, this annual event hosted in part by WIU College of Fine Arts and Communication celebrates jazz music and musicians. WIU students and faculty as well as groups from across the nation perform while keeping the spirit and the music of Al Sears alive.

In the basement of the university union, the WIU and Macomb communities can enjoy bowling, billiards, and an arcade. Sixteen bowling lanes, with electronic scoring, make spending an hour or more at the alley with friends an enjoyable experience. WIU's bowling facility was also the home lanes for a very successful collegiate club bowling team in the late 1990s and early 2000s. WIU's team, under the tutelage of coach Randy Widger, won national titles in 1999, 2001, and 2002.

For over 20 years hot-air balloon enthusiasts from all over the country have met in Macomb. WIU's Vince Grady Field has hosted the Macomb Balloon Rally since 1989. Local bands and WIU's own Jazz Studio Orchestra provide live music while all eyes are to the sky. The rally is the kind of special event that binds the campus community with the surrounding cities and towns.

Between the years 1996 and 2005, Macomb and WIU served as the summer training camp home of the NFL's St. Louis Rams. The Rams used WIU's facilities to prepare for another tough NFL season, and Rams players were frequently spotted around town during their down time at stores and restaurants. Hosting the Rams was an economic boost for the community as large crowds traveled to town each summer to watch the team practice. Other teams also visited WIU to play an exhibition game against the Rams at Hanson Field, including the Chicago Bears in 2004. The Rams' years in Macomb are remembered as a successful period in the franchise's history. Successful players like Kurt Warner, Marshall Faulk, Isaac Bruce, and Torry Holt donned the team's uniform during these years. While affiliated with Macomb, the Rams played in two Superbowls, winning the title in 2000.

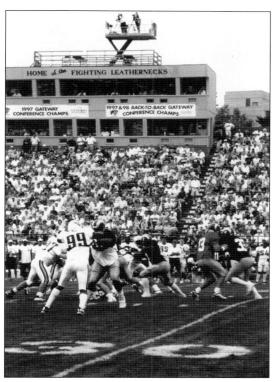

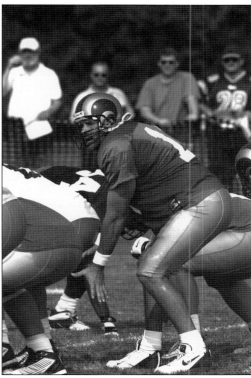

Western Courier

SERVING THE STUDENTS OF WESTERN ILLINOIS UNIVERSITY SINCE 1905

news ...
WIU students react to the national crisis, page 3.

op-ed ...
Wait for the facts until you accuse, page 8.

sports ...
Campus Recreation begins softball tournament, page 8.

today's weather ...
82 60

VOLUME 102, ISSUE 10 | Wednesday, September 12, 2001 | HTTP://WWW.WESTERNCOURIER.COM

TERRORISTS HIT U.S. HARD

By Cassina Sanders
EDITOR IN CHIEF

NEW YORK — Four commercial airplanes were hijacked yesterday morning by unknown culprits and set on a collision course with the World Trade Center, the Pentagon and Camp David.

Two planes crashed separately into the World Trade Center's north and south towers respectively.

The first plane — American Airlines flight 11, scheduled en route to Los Angeles from Boston — crashed into the north tower at approximately 8:45 a.m. EDT. The second plane — United Airlines flight 175 en route from

Dulles Airport in Washington, D.C., to Los Angeles — crashed into the south tower 18 minutes later.

American Airlines flight 77, also destined for Los Angeles, crashed into the Pentagon at 9:43 a.m.

Onlookers watched for an hour as rescue officials tried to evacuate and put out the blaze in the north and south WTC towers; the south tower collapsed, sending a massive cloud of debris and dust

to the street. The collapse injured many and killed even more, but an estimated number was not available at press time.

Eyewitnesses on CBS Channel 7 said that they could see people jumping from the buildings when the collapse began.

Officials said the two towers combined have about 50,000 employees and get about 10,000 visitors on an average day.

"If these terrorists wanted to get the attention of the U.S., they got it," Washington correspondent Bob Schieffer told CBS.

President George Bush, who was in Florida yesterday morning at the time of the attack, said that full resources of the federal government would be used to hunt down the

people responsible.

By mid-afternoon the debris and aftermath had destroyed the World Trade Center's No. 7 building, Oppenheimer Towers, the Merrill Lynch building and the American Express building — all surrounding the twin towers.

Sources are calling the tragedy the worst attack since Pearl Harbor and said there are indications that the threat is not over yet.

"As things progressed, it became clear that we were all targets," Sen Tom Harkin, D-Iowa, told WQAD Channel 8. "I think we spend close to $80 billion on intelligence alone; serious questions will have to be asked as to why we didn't know anything about it."

"We expect that this is the end, but we're not sure," Rep. Lane Evans, D-Illinois, told WQAD.

"We have not had our day yet, but we will have our day soon," he added.

All government buildings in Washington were closed for the rest of the day. In Chicago, the Thompson Center,

Hancock Building and Sears Tower were evacuated, along with most businesses downtown. Federal buildings and businesses in New York were evacuated as well.

In his address to the nation last night, President Bush said that all the businesses, including federal agencies and financial institutions, would be open for business and the nation would eventually be OK.

"These acts of mass murder were intended to frighten our nation into chaos, but they have failed," Bush said. According to the president, he's directed the full resources of the United States' intelligence and law enforcement community to find the terrorists responsible and that their will be no distinction made between the terrorists who committed the act and those who harbor them.

"America was targeted for attack because we are the brightest beacon for freedom and opportunity in the world, and no one will keep that light from shining," he added.

> "*These acts of mass murder were intended to frighten our nation into chaos, but they have failed.*"
>
> **George W. Bush**
> PRESIDENT OF THE UNITED STATES

American Airlines flight 11, flying from Boston to Los Angeles, crashes into one of the World Trade Center towers. The plane was carrying 81 passengers and 11 crew members.

United Airlines flight 175, flying from Boston to Los Angeles, crashes into the other World Trade Center tower. The plane was carrying 56 passengers and 9 crew members.

American Airlines flight 77, flying from Washington, D.C., to Los Angeles, crashed into the Pentagon in Washington, D.C., leaving a gaping space covering three of the five sides of the building. The plane was carrying 58 passengers and 4 crew members.

National tragedy hits closer to WIU than expected

By C. Ida Hoerdeman
NEWS EDITOR

WIU students congregated around televisions in the University Union, residence hall lounges and other buildings around campus and watched as terrorists attacked the United States.

Yesterday, in what many are referring to as the second Pearl Harbor, four planes were hijacked and crashed. The first two were crashed into the World Trade Center's towers. One crashed into the Pentagon, and one into a field south of Pittsburgh.

Although far from WIU's campus, the events had a major impact on the small town of Macomb.

Following a sudden cancellation of all classes, students who are normally not concerned with news switched from watching television sitcoms to live coverage and from music radio stations to news broadcasts.

Those with loved ones in the disaster areas anxiously awaited phone calls.

Local churches opened their

See **HOME** PAGE 5

Coordinated Plane Crash Called Worst Terrorist Strike in History
Student Reaction, SGA Suggestions, and University Help Inside this Issue

Here is the *Western Courier*, September 12, 2001, coverage of the terrorist attacks on New York and Washington.

Homecoming is a magical time on the WIU campus that includes the cool autumn breezes, the returning of proud alumni, the football game, and of course the homecoming parade. Both the WIU community and Macomb residents turn out to enjoy seeing the floats, bands, cheerleaders, grand marshal, and WIU's own Rocky. Student organizations are encouraged to decorate floats to best express the yearly homecoming theme and show off their purple and gold spirit.

WIUTV3 is a television news station run exclusively by students from the Department of Broadcasting. Appearing on University Channel 3, the program gives students, faculty, and Macomb residents news, weather, and sports reporting on a local and national scale. TV3 is another way WIU students take classroom knowledge and apply in real-world settings. In keeping current with trends in the industry, WIUTV3 has a Web site that is maintained by students from online journalism classes.

Alvin Goldfarb was named WIU's 10th president in 2002. He arrived after a distinguished career as a faculty member and administrator at Illinois State University. Under Dr. Goldfarb's leadership, WIU offered its first doctoral courses, in educational leadership. He has also been a vocal supporter of a new performing arts center for the Macomb campus and the construction of a new riverfront campus for WIU-Quad Cities in Moline.

Located just west of the WIU campus at 601 Wigwam Hollow Drive, the Islamic Center of Macomb serves the spiritual needs of Muslim students, faculty, and staff in the western Illinois region. The Islamic center is also keenly engaged in educating the non-Muslim campus community about the faith's traditions and customs. The center is an active member of the Macomb Area Interfaith Alliance and contributes positively to the diversity and strength of the entire region.

Groundbreaking on the new multicultural center, located on Murray Street, took place in September 2007. The facility will bring together many of the campus organizations charged with promoting a diverse campus, including the women's center, Casa Latina, the Gwendolyn Brooks Cultural Center, and the International Friendship Club. The building is scheduled for completion in 2009, with a spring 2009 grand opening. The multicultural center will be WIU's first "green" building with many environmentally friendly construction materials, a geothermal heating and cooling system, and a grass roof.

With the philosophy that a football stadium can be used year-round, renovations began in late 2006 to make the facility more multipurpose. The $5 million upgrades included making the facility handicapped accessible, new student bleachers, permanent bathrooms and concession areas, and an arched entry into the stadium from "the Pit," a favorite tailgating spot for WIU fans. A new press box and new offices are also planned.

Adjacent to Brophy Hall is the home of WIU's varsity tennis teams. A fence to protect players from wind encloses all eight hard-surface courts. WIU fields both men's and women's tennis squads, and they compete in the Summit Athletic Conference.

Since 1996, Dr. Eric Johnson has coached men's soccer, and under his leadership the program continues to reach new heights. In 2004, the men's soccer team made WIU history by capturing the school's first Mid-Con Conference Championship. This championship led to another first, WIU's first bid to the NCAA men's soccer tournament. Three WIU players were named first-team All-Conference for 2004.

WIU's women's basketball scored big during the 2004–2005 season as Mid-Con Conference Champions. By the season's end, the Westerwinds' string of 39 consecutive home victories was the longest in the nation. WIU was invited to participate in 2005–2006 preseason Women's National Invitation Tournament games for the first time in school history. The team was led by the Latvian-born star center Zane Teilane, who was drafted out of WIU by the WNBA's Detroit Shock.

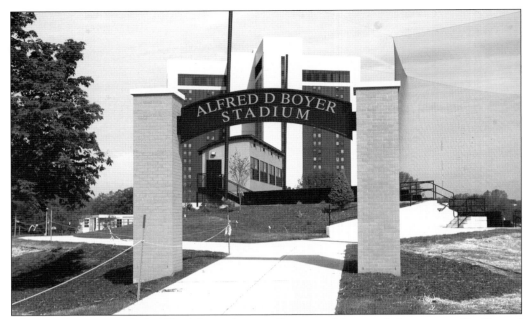

After graduating in 1972, Alfred Boyer has not forgotten his proud alma mater. Dedicated on May 6, 2006, Alfred D. Boyer Stadium is home to Leatherneck baseball. During the ceremony, Boyer announced he would make an additional donation, in honor of his brother Earl, for new lights, allowing the field to host night games. The beautiful stadium seats nearly 500 fans, and it boasts a state-of-the-art press box for print, radio, and television broadcasts.

Longtime physical education professor Mary Ellen McKee was honored by WIU with the completion of a new softball stadium bearing her name in 1998. The permanent home for Westerwinds softball comfortably seats 500 fans on bleachers alongside the infield. Dugouts, on either baseline, keep both teams protected from the elements, and the press box provides space for broadcast professionals. The stadium is overlooked by Brophy Hall on the north side of campus.

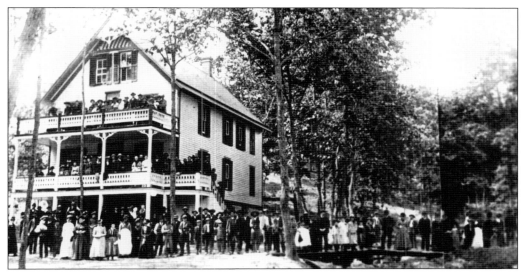

The Ira and Reatha T. Post Wildlife Sanctuary, more commonly called Vishnu Springs, was gifted to the WIU Foundation in 2003. The history of the 140-acre tract of land located in western McDonough County goes back to the 1870s when mineral springs were found on the property. The springs drew people from afar to partake of the water's "healing qualities." The Capitol Hotel, built on-site in 1889, offered lodging for visitors, and a small settlement developed. Its success, however, was short lived due to a series of ill-fated events. In the 1930s, Ira Post bought the property, refurbished the hotel, and reopened the property for his family and friends to enjoy. After Post's death, the property was left to his granddaughter, his youngest living heir. Because of this generous gift, WIU has a unique outdoor setting close to campus that can be utilized to supplement and enhance classroom learning. Additionally, the site houses one of McDonough County's most popular historic sites, the Capitol Hotel. The photograph above is how Vishnu appeared during its heyday as a tourist attraction. The photograph below shows what Vishnu looked like during the 1970s. (Courtesy of Holly Garbo.)

The current WIU Board of Trustees provides visionary leadership for the university. Prior to January 1996, WIU was led by the Board of Governors of State Colleges and Universities. At that time, WIU got its own governing body. During the 2007–2008 academic year, members of the board of trustees included Robert Cook, late of Macomb; Carolyn Ehlert, Milan; William L. Epperly, Chicago; Bill Griffin, Macomb; J. Michael Houston, Springfield; Jessie Kallman, Moline; and Steven L. Nelson, Moline.

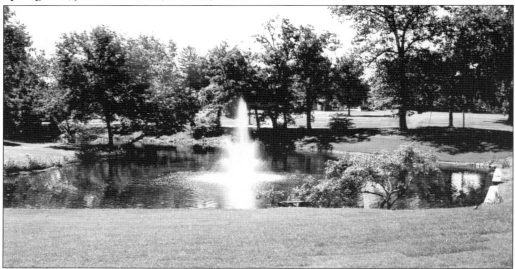

During the summer of 2008, WIU's physical plant staff worked hard at improving the appearance of Lake Ruth, an icon on the WIU campus. The improvement process involved removing nearly 2,500 tons of sediment from the lake's floor, working to control algae, adding native flowers and grasses to the shoreline, and installing a fountain. Furthermore, the Department of Biology faculty and students selected appropriate fish to stock the lake and will continue to work to ensure Lake Ruth's ecological health.

Getting to and from Macomb can be challenging due to the city's relative geographic isolation. Thankfully, Amtrak recognized this challenge and since 1971 has provided daily round-trip rail service between Chicago and Quincy, serving Macomb, on the *Illinois Zephyr* train. In 2006, due to increased demand, a second daily train was added. Named the *Carl Sandburg*, the additional train was well received by the WIU community. WIU has been a strong advocate for rail service to Macomb, as it is a quick, safe, and cost-effective method of transportation.

WIU's campus community has long welcomed international students and benefited from their unique contributions. Since the fall semester of 2005, some of those students have called the International House home. The redbrick building, located on the western edge of campus on West Brooks Circle, was originally constructed in 1994 and served as a sorority house until the university purchased it. Currently, the building houses 32 students in double-occupancy rooms, and it features a library, computer facilities, and a large kitchen. The International House provides year-round accommodations in a comfortable and homelike environment.

WIU's presence in the Quad Cities area reaches back for decades. As the state university located closest to one of the state's largest population centers, WIU saw an opportunity to serve this part of the state. Throughout the 1970s and 1980s, WIU taught classes at various locations throughout the Quad Cities, including the Quad City Graduate Center in Rock Island, the former John Deere Elementary School in East Moline, the former Villa de Chantal boarding school in Rock Island, and Black Hawk College in Moline. In the late 1980s, the Rock Island Regional Undergraduate Center opened to formalize WIU's commitment to the Quad Cities. WIU upgraded its facilities in the Quad Cities greatly in 1994 when it acquired the former IBM building on Sixtieth Street in Moline, next to Black Hawk College. After a multimillion-dollar renovation, the building was ready for a 1997 dedication. Almost immediately the facility was too small for the growing campus, offering an impressive blend of undergraduate and graduate programs.

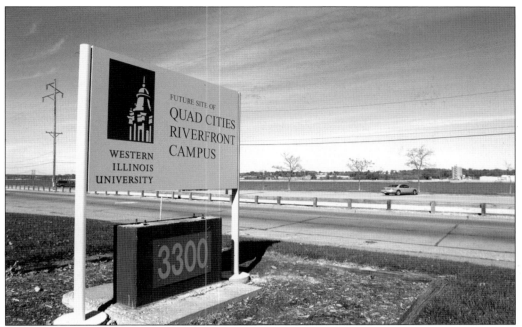

In 2004, John Deere and Company donated to WIU 20 acres along the Mississippi River in downtown Moline to build a modern, planned campus. The campus, located at 3300 River Drive, Moline, will be developed in stages, and the City of Moline plans to develop adjacent properties into an urban technology corridor. The first phase includes renovating much of the former John Deere Technical Center. WIU is dedicated to serving the needs of the Quad City area, and its new riverfront campus will serve as a springboard for the continued redevelopment of downtown Moline and the Quad Cities' future economic and cultural growth.

Quite possibly no aspect of the college experience has changed more in the last 20 years than the quality of off-campus housing and the expectations students have for it. Slowly dying are the days of countless students crowding together in a run-down rental house or dilapidated apartment complex. Students (and in many cases, their parents) are demanding high-quality off-campus housing that bears no resemblance to the apartments of yesteryear. Luxuries previously unheard of like cable television, workout facilities, tanning beds, dishwashers, and in-unit washers and dryers are becoming standard student apartment amenities. The new housing trend has not escaped Macomb, as a number of new apartment complexes have sprung up around town. Most of these new apartments are located in the previously undeveloped areas south and west of campus, but some are integrated into the established student neighborhoods along Adams Street. Aspen Court Apartments has built townhomes at the corner of Adams and Charles Streets (pictured above) and townhomes and apartments on West Jackson Street. Turnberry Village (pictured below) is located southwest of campus on Wigwam Hallow Road, between Adams and West Jackson Streets.

Another fine example of WIU's impact on the regional economy is the Illinois Small Business Development Center and the Western Illinois Business and Technology Center. Located west of campus on North Pearl Street, the center is a collaborative project of WIU, the United States Small Business Administration, the Illinois Department of Commerce and Economic Development, and the Illinois Institute for Rural Affairs. It exists to provide business counseling and training to help regional residents start, grow, and sustain businesses.

Documents and Publication Services, or DPS, moved to a new facility on the north edge of campus behind the physical plant in late 2006. The new building streamlined DPS services by consolidating the operations into one facility. The move was met with concern due to the building's relative isolation from the rest of campus. Those concerns turned out to be warrantless, and the increased efficiency of the single facility has made DPS a successful campus resource.

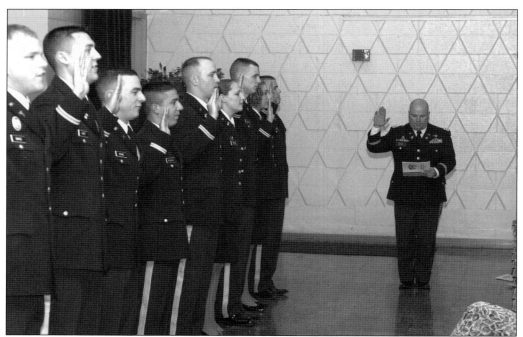

Reserve Officers Training Corps, or ROTC, prepares students to become future leaders in the United States Armed Forces. This four-year program qualifies both male and female cadets to be commissioned as second lieutenants in either the air force, army, marine corps, or navy. WIU's Army ROTC is a three-time recipient of the prestigious General Douglas McArthur Best Battalion in the Midwestern United States award, in addition to capturing four honors for best ROTC battalion in the 10th Brigade. Below, WIU ROTC student soldiers are dressed in their camouflage suits for a training exercise.

In an ever-increasing global society, WIU works hard to make the world available to the entire WIU community. The Center for International Studies is the campus center for international programs, including study abroad for WIU students, the Western English as a Second Language (WESL) program, and the clearinghouse for other international students interested in pursuing a degree at the school. WIU encourages the internationalization of campus and works diligently at that admirable goal.

WIU's university-owned bookstore is located in the union. The recently expanded 11,000-square-foot facility is where students can purchase textbooks for their classes, school supplies, and an impressive assortment of authorized WIU merchandise. The other major campus area bookstore is Chapmans Book and Office Supply, located across from campus on West Adams Street.

In 2006, WIU's first group of doctoral students began coursework on their doctorate in education in educational leadership degree. WIU's venture into doctoral studies is designed to reflect the school's growing stature and importance as an institution focused on research. In the summer of 2008, three students defended their dissertations, the last step toward the doctoral degree. Pictured here is Jay Marino (in dark jacket) with faculty members, from left to right, Sandra Watkins, Donna McCaw, Greg Montalvo, and College of Education and Human Services dean Bonnie Smith-Skripps. The other two students were Michael Oberhaus and Vicki VanTuyle.

The WIU Foundation is the organization charged with managing private and other external support to strengthen university programs and enrich the educational experience for WIU students. The foundation is engaged in numerous activities, including providing student scholarships, funding faculty and student research, and supporting local cultural activities.

Commencement at WIU is a special time celebrating achievement, hard work, and knowledge. Whether graduates are earning their bachelor's, master's, or doctoral degrees, most reminisce fondly upon their time at WIU. Graduates wear traditional regalia of black gowns, mortarboard caps, and different colored tassels representative of each of the university's colleges. Graduate students are awarded hoods, based upon their field of study. Convocation occurs at the end of both fall and spring semesters and features speeches by faculty members, students, and an inspirational address by a keynote guest. Graduation marks a bittersweet day for students as they leave WIU and head toward their futures.

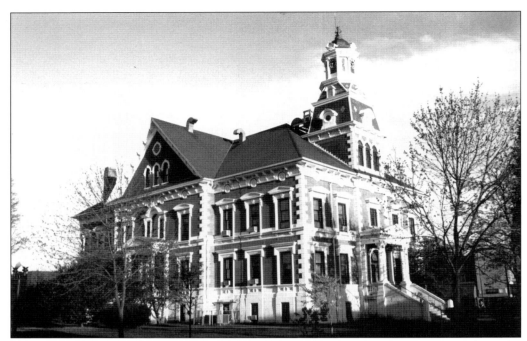

The histories of WIU and its host community, Macomb, are closely intertwined. As the largest community in a 50-mile radius, Macomb is the first choice for WIU students and faculty looking for shopping, dining, and entertainment. The centerpiece of Macomb is its classic brick courthouse, located on the town square. Construction on the courthouse began in 1868, and the building is still used today. Chandler Park, located just off the square, is named after influential local resident C. V. Chandler. The park, complete with a white gazebo, is a popular place for local residents to relax during warmer weather and listen to music.

In addition to service organizations affiliated with WIU, Macomb is a community rich in service organizations seeking to make the quality of life better for all residents. These organizations include the Knights of Columbus, American Legion, Kiwanis International, Rotary International, Elks Club, VFW, and Lions Club. The City of Macomb's pride in hosting WIU is evidenced by its inclusion of "Home of WIU" on this city water tower, located on the northern edge of town. Macomb is proud of WIU, and WIU is grateful for the goodwill it receives from its host community.

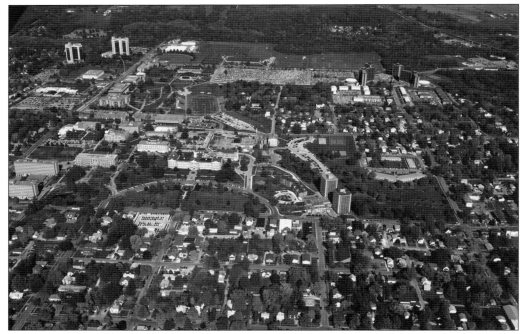

Here are two modern pictures of the WIU campus. Above is an aerial view of most of the grounds, and below is a night photograph of the northwest corner of campus, with Stipes and Morgan Halls in view.

BIBLIOGRAPHY

Hallwas, John E. *First Century: A Pictorial History of Western Illinois University*. Macomb: Western Illinois University, 1999.

Hicken, Victor. *The Purple and the Gold: The Story of Western Illinois University*. Macomb: The Western Illinois University Foundation, 1970.

Van Cleve, Edward E. *Normal School Extension in the Military Tract*. Macomb: Western Illinois State Normal School, 1913.

"Golden Anniversary." Pamphlet, Western Illinois State College Vol. XXIX, October 1949.

ACROSS AMERICA, PEOPLE ARE DISCOVERING
SOMETHING WONDERFUL. *THEIR HERITAGE.*

Arcadia Publishing is the leading local history publisher in the United States. With more than 3,000 titles in print and hundreds of new titles released every year, Arcadia has extensive specialized experience chronicling the history of communities and celebrating America's hidden stories, bringing to life the people, places, and events from the past. To discover the history of other communities across the nation, please visit:

www.arcadiapublishing.com

Customized search tools allow you to find regional history books about the town where you grew up, the cities where your friends and family live, the town where your parents met, or even that retirement spot you've been dreaming about.